Rachel Whiteread

Walls Doors

[and]

Floors Stairs

Rachel Whiteread

Herausgegeben von / edited by
Eckhard Schneider

Mit Essays von / with essays by
Mario Codognato
Richard Cork
Richard Noble
Juhani Pallasmaa

Kunsthaus Bregenz

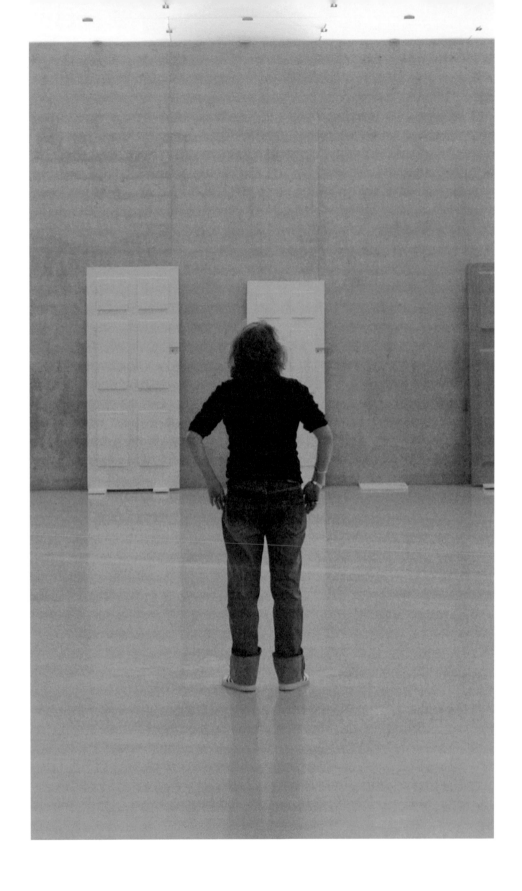

Inhalt

Contents

Konstruktion des Ephemeren
Constructing the Ephemeral
Eckhard Schneider
[7]

Installationsansichten
Views of Installations

Stairs

Stein gewordene Stille
Petrified Silence
Juhani Pallasmaa
[22]

Floor Pieces

Die Welt ist die Gesamtheit der Tatsachen, nicht der Dinge
The World Is the Totality of Facts, Not of Things
Mario Codognato
[38]

In-Out – I-XIV

Spurenlese
The Meaning of What Remains
Richard Noble
[66]

Room 101

Rachel Whiteread und Room 101
Rachel Whiteread and Room 101
Richard Cork
[94]

Anhang
Appendix

Ausgestellte Arbeiten
Exhibited Works
[113]

Werkfamilien
Families of Works
[115]

Biografie / Bibliografie
Biography / Bibliography
[116]

Autoren
Authors
[120]

„In der Kunst gibt es keine stärkeren Werke als diejenigen, die sich selbst keine Komödie der Kunst, der Kunstgeschichte und der Geschichte der Ästhetik mehr vorspielen."

Jean Baudrillard

"In art, there are no greater works than those which no longer perform comedies of art or the history of art and aesthetics to themselves."

Jean Baudrillard

Konstruktion des Ephemeren

Eckhard Schneider

„Walls, Doors, Floors and Stairs" ist der sachlich klingende, dennoch geradezu programmatische Titel für die Werkschau von Rachel Whiteread im KUB. Gezeigt werden vier Schlüsselwerke bzw. Werkgruppen für das zentrale Thema in ihrem Schaffen, das der Architektur, im Besonderen der des Hauses. Die Arbeiten stammen aus den Jahren 2000 bis 2004. Die repräsentative Auswahl wird im Erdgeschoss mit dem Thema „Stairs", dem monumentalen Treppenhaus Untitled (Upstairs) von 2000/2001 eröffnet. Es folgen im ersten Stockwerk die „Floors" mit den drei Bodenarbeiten Untitled (Bronze Floor), 1999/2000, Untitled (Cast Iron Floor), 2001, und Untitled Floor (Thirty-Six), 2002, und im zweiten Stockwerk „Doors" mit der neuen, speziell für das Kunsthaus Bregenz geschaffenen Werkserie In-Out von 2004 – 14 Türabgüssen von Londoner Häusern. Den Abschluss der Ausstellung bildet „Walls" mit Room 101 aus dem Jahr 2003.

Die Idee der Architektur als elementarer sozialer und emotionaler Raum für das Ich des Menschen und ihre skulpturale Transformation bildet das Rückgrat im gesamten Werk von Rachel Whiteread. Bereits 1990, nur zwei Jahre nach Closet, der ihrer Aussage zufolge ersten Skulptur, entsteht Ghost. Es ist der Abguss eines Wohnzimmers aus einem viktorianischen Haus. Die frühen Möbelabgüsse sind zwar Ausgangspunkt für ihre skulpturale Idee einer Metapher „for human being", aber mit der räumlichen Expansion im Maßstab realer Architektur vollzieht Rachel Whiteread einen entscheidenden künstlerischen Schritt. Im Vergleich wird deutlich, wie grundlegend diese

Constructing the Ephemeral

Eckhard Schneider

"Walls, Doors, Floors, and Stairs" is the sober, yet quite programmatic title of the Rachel Whiteread exhibition at the Kunsthaus Bregenz. It presents four major works, or rather groups of works, on the central theme of her art which is architecture, in particular that of the house. The exhibits date from the years 2000 to 2004. The representative show opens on the ground floor with the subject of stairs in the form of the monumental staircase mould Untitled (Upstairs) of 2000/2001. The displays continue on the first floor with the "Floors" of Untitled (Bronze Floor), 1999/2000, Untitled (Cast Iron Floor), 2001, and Untitled Floor (Thirty-Six), 2002, and on the second floor with the theme of "Doors", including the new series In-Out of 2004, which the artist created specially for the Kunsthaus Bregenz. It consists of fourteen casts of doors from London houses. The wall sculptures, including Room 101, 2003, round off the exhibition.

The idea of architecture as a primal social and emotional space housing man's self, and its sculptural transformation forms the basis and backbone of Rachel Whiteread's entire artistic output. As early as 1990, only two years after Closet (which she says was her very first sculpture) the artist created Ghost, the cast of a Victorian living room. Though her early furniture casts were the starting point for her idea of a sculptural metaphor for the human being, it is with the expansion into real-scale three-dimensional architectural space that Rachel Whiteread took a decisive leap forward in her art. In comparison with her earlier work, it becomes clear how decisive

Entscheidung für das weitere künstlerische Schaffen von Rachel Whiteread war.

Kennzeichnend für jede Objekt-Mensch-Beziehung ist die Dominanz. Jeder Stuhl, Tisch, jeder Gebrauchsgegenstand, der den elementaren Bedürfnissen wie dem Schlafen oder Sitzen dient, funktioniert durch seine überschaubare Größe, seinen unmittelbaren Nutzen, seine Statik und vor allem seinen dienenden Sinn wie eine soziale Prothese des Alltags. Umso mehr, als Rachel Whiteread nicht die tragende funktionale Konstruktion zur Skulptur macht, sondern das Unbedeutende der Konstruktion, den von dem Objekt umschlossenen, an sich nicht sichtbaren Leerraum. Die Raum-Mensch-Beziehung ist dagegen viel komplexer und eher von emotionaler und zeitlicher Latenz geprägt. Im Raum ist der Mensch von schützenden Wänden umgeben, zwischen denen er sich bewegt. Der Raum gleicht einer zweiten Haut, die sich wie ein schützender Kokon mit Abstand um den Menschen legt. Gleichzeitig speichert der Raum die persönliche Geschichte und Aura seiner Bewohner und wird so zum physisch-psychischen Gedächtnis.

Jedes bedeutende künstlerische Werk besitzt einen bestimmten historischen Augenblick, in dem die richtigen Entscheidungen fallen müssen. Neben der Frage nach dem Konzept gehört dazu die Entscheidung über die Materialien und die Wahl adäquater Arbeitsprozesse. Bei Rachel Whiteread ist es die Idee der Transformation des „human being" in skulpturale Objekte, ihre Umformung über ein Negativ-Gussverfahren in Verbindung mit flüssigen Werkstoffen, die zu einer festen Form erstarren. Mindestens ebenso entscheidend ist der Entschluss, im größeren Maßstab der Architektur zu arbeiten. Rückblickend sagt Rachel Whiteread 2001 in einem Interview mit Craig Houser: „Ghost wurde von Hand gegossen, zum großen Teil von mir ganz allein. Es war das erste Stück, bei dem ich

it was for all her further artistic creations. One characteristic of every relationship between man and object is dominance. Every chair or table, every object in daily use that serves man's basic needs like sleeping or sitting, is effective because of its manageable size, immediate utility, static stability and, above all, its purpose of giving service as an everyday social prop. All the more so, as Rachel Whiteread does not make a sculpture of functional construction, but of its unimportant features, i.e. of the actually invisible void enclosed within the object. The man-object relationship, however, is much more complex and rather determined by emotional and temporal latency. In an interior space, a person is surrounded by and moves around between protective walls. The room seems like a second skin which forms a cocoon with intermediate space around him or her. At the same time, it stores the personal story and aura of the people who live in it and thus becomes their physical-psychological memory.

Every significant work of art is the result of a certain historic moment in which the right decisions had to be taken. These include not only the basic concept, but also the choice of materials and the appropriate methods. For Rachel Whiteread, it was the idea of transforming human beings into sculptural objects, converting them by means of a negative-mould casting process, using an initially fluid material which then hardens. At least as important was her decision to work on the larger scale of architecture. Looking back, in a 2001 interview with Craig Houser, Rachel Whiteread said, "Ghost was hand cast and I made a lot of it entirely on my own. It was the first piece in which I realised that I could absolutely disorient the viewer. While I was making it, I was just seeing one side at a time. I then took all the panels to my studio and fixed them to a

feststellte, dass ich den Betrachter vollkommen verwirren konnte. Während ich daran arbeitete, sah ich ja immer nur eine Seite auf einmal. Dann brachte ich alle Abgussplatten in mein Atelier und befestigte sie an einem Gerüst. Als wir das Ganze schließlich aufrichteten, merkte ich erst, was ich da überhaupt geschaffen hatte. Da war die Tür direkt vor mir, und ein Lichtschalter mit seiner Rückseite nach außen gekehrt, und ich dachte: ‚Ich bin die Wand. Genau das hab' ich getan, mich selbst zur Wand gemacht!'"

Die Aussage klingt so selbstverständlich wie erschreckend. Der Mensch ist auf einen Schlag unbehaust, ausgesperrt, er erfährt Leere und gespeicherte Zeit, ohne länger Teil davon zu sein. Der skulpturale Guss wird zum schweigenden Monument des eigenen Seins.

Die wesentlichen künstlerischen Regeln sind damit erarbeitet und genannt. Bezogen auf den skulpturalen Prozess wird Leere zur Skulptur. Thematisch wird die Alltagswelt des Menschen mit seinen Relikten aus Möbeln und Räumen zum Monument der Erinnerung gemacht. Der Betrachter erhält über das im doppelten Sinne oberflächliche Sehen hinaus die Tiefe der Vorstellung zurück, und im kunsthistorischen Diskurs schließlich gibt Rachel Whiteread den skulpturalen Objekten jene Aura zurück, die ihnen von Künstlern wie Donald Judd und Carl Andre (auf die sie sich u.a. in ihrem Werk auch bezieht) entzogen wurde.

Jean Baudrillard prägt in einem Gespräch mit Jean Nouvel, bezogen auf seine Vorstellung von Architektur, den Begriff von „einzigartigen Objekten". Er meint damit keine „Wunder der Architektur [...] also nicht das architektonische Empfinden dieser Gebäude, sondern die Welt, die sie wiedergeben". Eine Definition, die wie geschaffen scheint für die Werke von Rachel Whiteread. Besonders, wenn man ihre skulpturalen Objekte im historischen Kontext zum

framework. When we finally put the piece up, I realised what I had created. There was the door in front of me and a light switch back to front and I just thought to myself: 'I'm the wall. That's what I have done. I've become the wall.'"

This statement sounds as logical as it appears shocking. All of a sudden, man finds himself unhoused, locked out, experiencing emptiness and stored moments of time without any longer being part of it all. The sculptural cast becomes a silent monument to its own existence.

The essential artistic rules have thus been fixed by action, and named. In terms of the sculptural process, emptiness changes into sculptural mass. The everyday world of man and his relics of furniture and rooms is turned into a memorial. Beyond literally and figuratively superficial vision, the viewer regains the depths of his/her imagination and, finally, in terms of the art-historical discourse, Rachel Whiteread reinvests sculptural objects with that aura which other artists like Donald Judd and Carl Andre (who she refers to in her work) divested them of.

In a conversation with Jean Nouvel about his understanding of architecture, Jean Baudrillard used the term "unique objects" by which he did not mean "architectural wonders [...] that is not the architectural sensibility of these buildings, but the world they reflect." This definition seems as if formulated specially to describe Rachel Whiteread's creations, in particular, if one places her sculptural objects in the historical context of the œuvre of Donald Judd with whom she shares the reduction of things to the quintessential 'reality of the real'. Judd defines his system of specific objects according to their artistic eminence, omitting every mimetic reference and making only that visible, which must be regarded as factual. Rachel Whiteread's objects, on the contrary,

Werk von Donald Judd sieht, mit dem sie die Reduktion auf den Inbegriff des Eigentlichen gemein hat. Judd definiert sein System der spezifischen Objekte allerdings in ihrer kunsteminenten Bedeutung, sodass jeglicher mimetische Bezug entfällt und nur noch das in Erscheinung treten kann, was als Faktisches zu sehen ist. Rachel Whitereads Objekte dagegen scheinen im Sinne Baudrillards die Welt, die sie vertreten, wiederzugeben. Was sie allgemein gültig und gleichzeitig einzigartig macht. Allerdings besitzen sie einen anderen verborgenen Sinn. Sie repräsentieren nicht mehr nur das Sichtbare des Objekts oder der Architektur, sondern sie repräsentieren gleichzeitig das ihnen eingeschriebene Unsichtbare. Alles was unbestimmt, mental, physisch und emotional spürbar bleiben kann, wird in der Rätselhaftigkeit des Objekts zur Anschauung gebracht. Es ist ein gewagter künstlerischer Spagat, faktisch bestimmt und gleichzeitig emotional offen zu sein. Rachel Whiteread gelingt damit eine Verfremdung, die bewirkt, dass die Wahrnehmung des Sinnlichen nicht nur in die Materie, sondern auch in das Immaterielle übersetzt wird.

So merkwürdig es klingen mag, besitzen vor allem die architekturbezogenen Werke von Rachel Whiteread auch filmisches Denken. Die Grundstrukturen des Films sind Bewegung, Geschwindigkeit und Gedächtnis. In den Werken Whitereads scheinen diese Prinzipien antithetisch zum Stillstand gebracht zu sein. Die Bewegung derer, die die Architekturen und Objekte bewohnten und benutzten, sind eingegossen im Behälter des Stillstands und des Schweigens. Umso entscheidender wird die Bewegung des Betrachters am Objekt und um den Architekturkörper herum. Dabei geht es nicht nur um das, was man sieht, sondern auch um das, was man sich in einer Abfolge von Sequenzen als Erinnerung einprägt. Unverzicht-

complying with Baudrillard's understanding, seem to reproduce the world they represent. This makes them both universally valid and unique. However, they have another, hidden meaning. They no longer present only the visible aspects of the object or the architecture, but also the invisible enclosed within them. All that is diffuse, yet mentally, physically or emotionally perceptible, is brought to light in the mystery of the object. It is a risky artistic form of splits to be lead by facts and to be emotionally open at the same time. Rachel Whiteread succeeds in making the facts appear unfamiliar so that one's perception of the sensual is translated not only into matter, but also into the immaterial.

It may sound odd, but Rachel Whiteread's architectural casts also convey a cinematic approach. The basic elements of a film are movement, speed and memory. In Whiteread's creations, antithetically, these principles seem to have been brought to a standstill. The movements of those who used and inhabited the objects and architectural structures are cast in the container of stoppage and silence. All the more significant is the movement of the viewers around the object or the architectural cast. The important thing is not only what they see, but also what they take in and store into memory as a sequence of views from all angles. For this, the many details, the 'impressions' of the hidden interior space as well as the viewers' changing interpretations, their growing knowledge or impressions of the physically, materially recorded memories of times gone by are indispensable.

Again, Peter Zumthor's architecture stands the test as an 'ideal-typical container' also for Rachel Whiteread's works. Zumthor's concept of structural and material reduction down to the basic room-shaping elements promotes the interaction of architecture and work of art.

bar sind dabei die vielen Details, die inneren Abdrücke des verborgenen Raums ebenso wie die wechselnden Vorstellungen des Betrachters, das Anwachsen einer Anmutung über die verfestigten Erinnerungen an eine andere Zeit.

Die Architektur von Peter Zumthor bewährt sich erneut als idealtypischer „Behälter" auch für das Werk Rachel Whitereads. Zumthors Idee einer strukturellen und materiellen Komprimierung auf die Grundelemente des Raums ermöglichen die gegenseitige Teilhabe von Werk und Architektur. Es ist diese Abstraktion der Typologie des Raums und die reale Konkretheit der Materialien, die wie ein Echo die Werke ins Recht setzen und ihre Wirkung aufs Reinste freilegen. In diesem Sinne sind Whitereads Werke der Architektur in einer ihnen gleichwertigen Architektur wie Zwillinge derselben Vollendung.

Ich danke allen, die in den letzten drei Jahren seit der ersten Idee für die Ausstellung zu dieser Vollendung beigetragen haben, im Besonderen den Leihgebern. Peter Zumthor ausdrücklich eingeschlossen, danke ich dem Team des Kunsthaus Bregenz und dem Studio-Team von Rachel Whiteread, den guten Ratgebern und Unterstützern wie Mark Francis und Cristina Colomar von der Gagosian Gallery sowie den Sponsoren der KUB-Arena, Montfort Werbung und DMG, namentlich Richard Morscher und Rüdiger Kapitza, dem Haussponsor Hypo Landesbank sowie Zumtobel Staff und dem Land Vorarlberg. Außerdem danke ich dem Buch-Team unter der Leitung von Katrin Wiethege zusammen mit Caroline Schilling und dem Typographen Walter Nikkels. Ganz besonders herzlich aber danke ich Rachel Whiteread für ihr Werk und ihre menschliche Wärme in einer vertrauensvollen Zusammenarbeit.

Eckhard Schneider
April 2005

It is this abstraction of the typology of interior space and physical material reality that – like an echo – brings these sculptures into their own and reveals their effects in the purest manner. In this sense, Whiteread's architectural creations are like the siblings of Zumthor's architecture – of equal value and perfection.

I wish to thank all those who, in the past three years since the idea first came up, have prepared and contributed to creating this exhibition, and special thanks to the lenders. Peter Zumthor is expressly included in their number, as are the teams of the Kunsthaus Bregenz and Rachel Whiteread's studio, our good advisors and supporters Mark Francis and Cristina Colomar of the Gagosian Gallery, and KUB-Arena sponsors Montfort Werbung and DMG, Richard Morscher and Rüdiger Kapitza, KUB's general sponsor Hypo Landesbank, as well Zumtobel Staff and the government of Vorarlberg province. I also thank the publication team, led by Katrin Wiethege, with Caroline Schilling and typographer Walter Nikkels. Most especially I thank Rachel Whiteread for her work and her warmth throughout our collaboration based on trust and understanding.

Eckhard Schneider
April 2005

Installationsansichten

Installationsansichten
Kunsthaus Bregenz
9. April bis 29. Mai 2005

Views of Installations
at Kunsthaus Bregenz
April 9 to May 29, 2005

Fotos / Photos:
Nic Tenwiggenhorn
© VG Bild-Kunst, Bonn 2005

Erdgeschoss / Ground Floor
KUB-Arena,
Untitled (Upstairs), 2000/2001
[13]

1. Stock / First Floor
Untitled (Bronze Floor), 1999/2000;
Untitled (Cast Iron Floor), 2001;
Untitled Floor (Thirty-Six), 2002
[14]

2. Stock / Second Floor
Werkserie / Series **In-Out – I-XIV**, 2004
[15]

3. Stock / Third Floor
Untitled (Room 101), 2003
[18–19]

Views of Installations

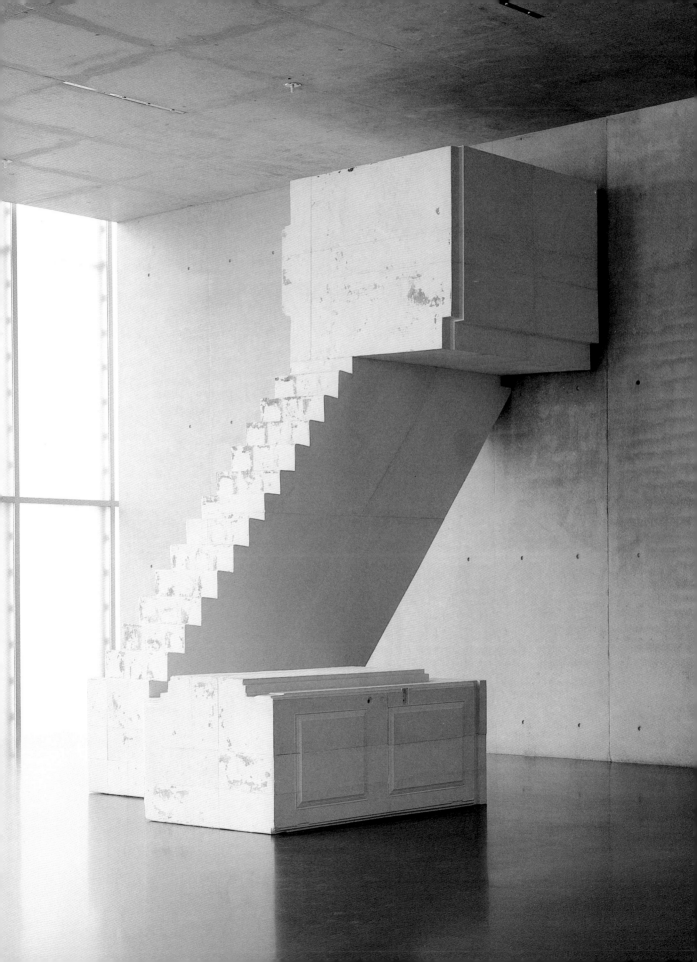

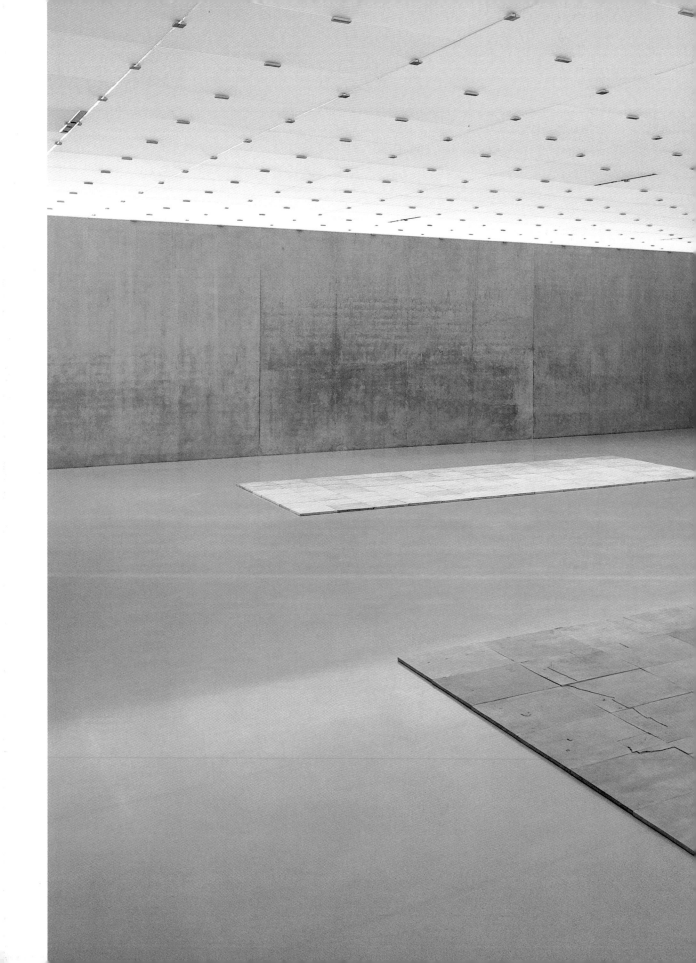

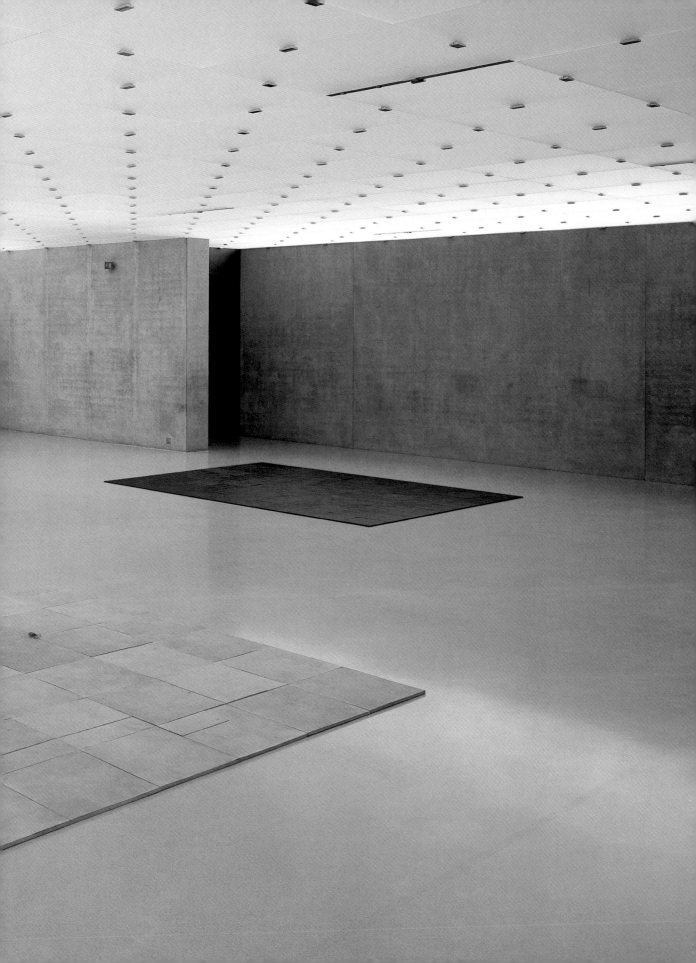

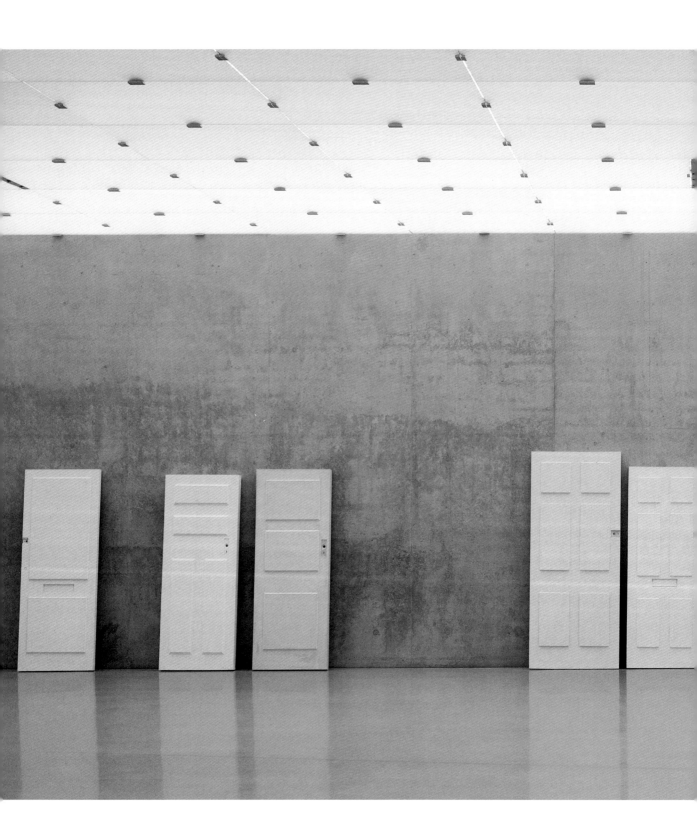

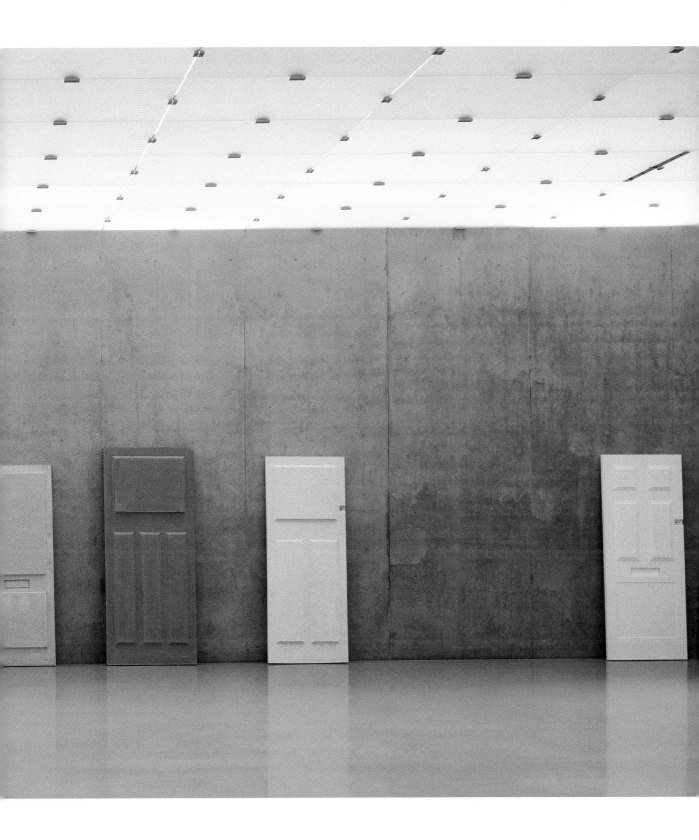

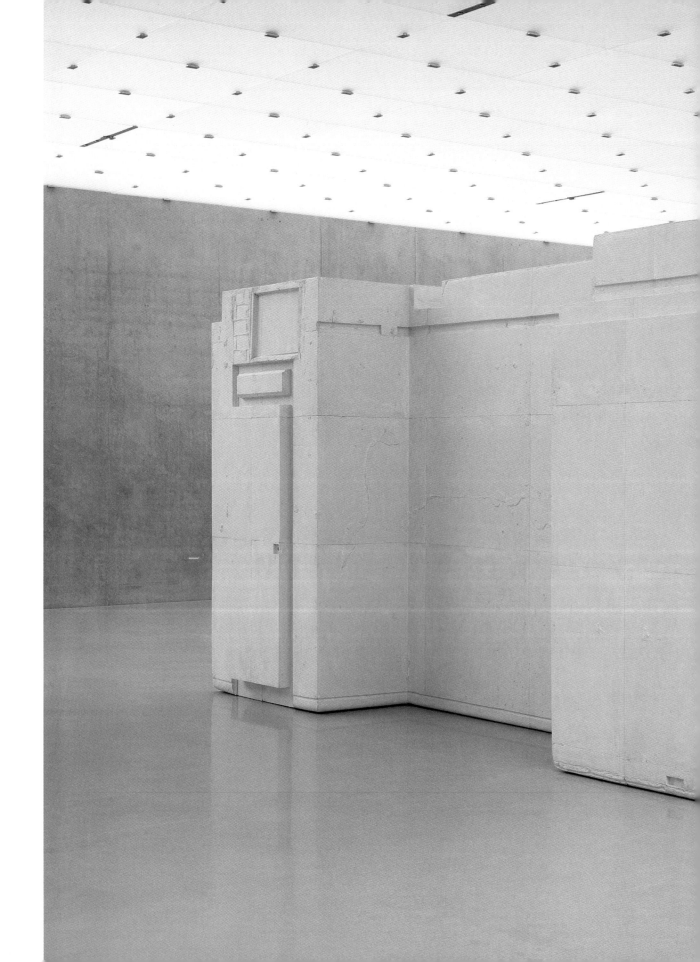

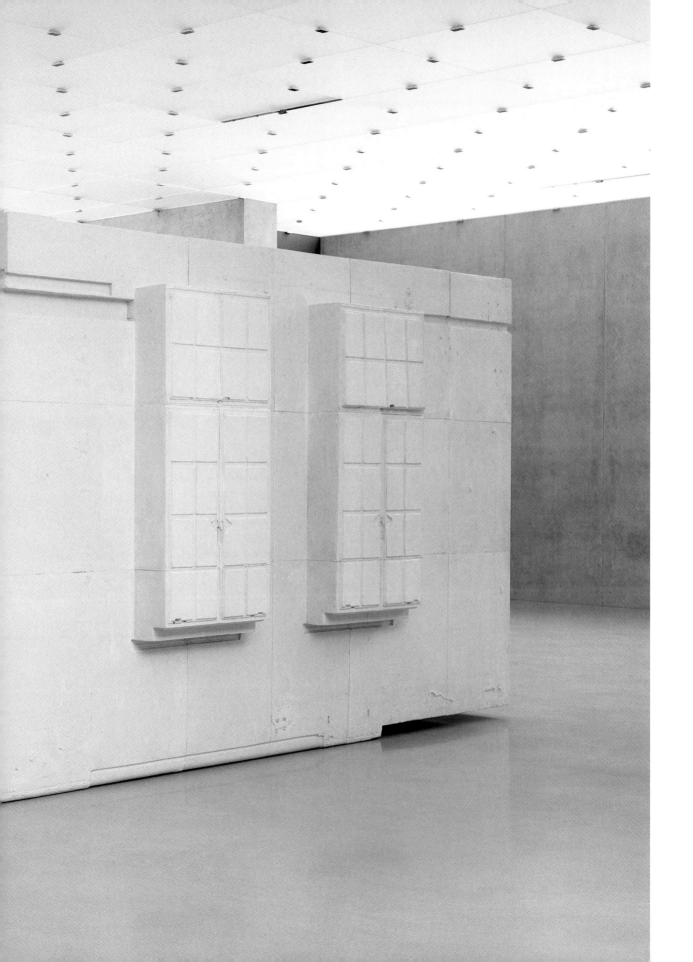

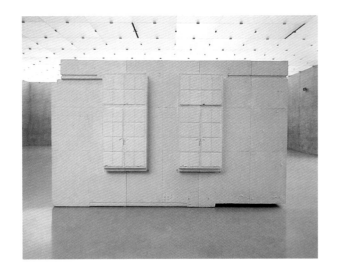
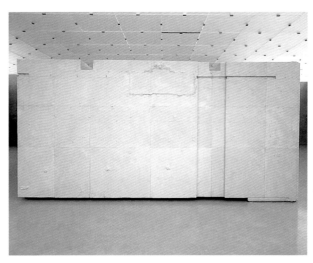
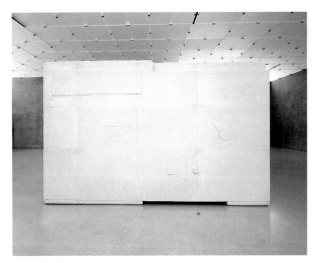
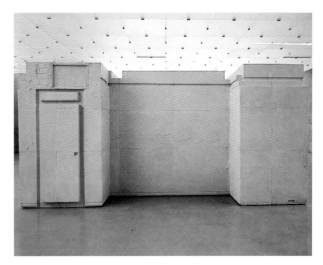

Stairs

Stein gewordene Stille

Juhani Pallasmaa

Rachel Whitereads plastische Arbeiten aus Gebrauchsgegenständen und zweckbestimmten Räumen bewegen sich im Spannungsfeld zwischen ihrer ursprünglichen Nützlichkeit und ihrer neu erworbenen Nutzlosigkeit. Sie negieren ihren Zweck und verwandeln sich in Symbole. Während wir die stofflichen Strukturen von Möbeln nutzen, ‚versteinert' Whiteread den ungenutzten Raum dieser Einrichtungsgegenstände. Und so, wie wir die Leere des Raumes ihn bewohnend füllen, heben ihre Abgüsse den Raum auf – und folglich die Möglichkeit seiner Inbesitznahme. Der Betrachter wird aus dem Raum herausgestoßen und so in die Rolle des außenstehenden Beobachters gezwungen. Whitereads architektonische Einbalsamierungen machen uns in aller Deutlichkeit bewusst, dass jede Oberfläche eines Gegenstands oder eines Raumes eine Grenze darstellt. Der Betrachter schaut auf die verhüllende Mauer des Vertrauten und kann nichts sehen. Er verspürt zugleich Neugier und Schuld, freudige Erregung und Frustration. Whitereads Holocaust- Mahnmal in Wien, 2000, verwandelt den verborgensten und vernachlässigsten Bereich eines Zimmers – den Raum zwischen Wand und Bücherregal – in eine öffentliche Fassade. Das Innere wird zum Äußeren, Häuslichkeit zum Stadtraum, das Verborgene zum Schaustück für die Öffentlichkeit.

Es fällt uns schwer, die Rückverwandlung des Raumes in Masse, der Leere in Fülle, der Transparenz in Undurchsichtigkeit (oder umgekehrt) zu erkennen oder zu verstehen. Die Gegensätze von massiv und leer, Gussform und gegossener Form sind so fundamental, dass wir bei dem Versuch, diese Gegensatz-

Petrified Silence

Juhani Pallasmaa

Rachel Whiteread's sculptural works, generated from actual utilitarian objects and spaces, are suspended between their initial utility and their newly acquired uselessness. They negate their very purpose and turn into signs and icons. Whereas we utilize the material structures of furniture, Whiteread petrifies the useless spaces around these domestic objects, and as we occupy the void of space, her casts annihilate space and, consequently, the very possibility of occupation. The spectator is pushed out of the space and forced into the position of an outside observer. Whiteread's architectural embalmings make us intensely aware of the boundary surface that delineates an object or a space. The viewer gazes at the enveloping boundary of intimacy, unable to see; the experience is a combination of curiosity and guilt, excitement and frustration. Her **Holocaust Memorial** in Vienna, 2000, turns the most hidden and neglected space of a room between the wall and the book case into a public façade; the interior turns into exterior, domesticity into urbanity, secrecy into an object of public gaze.

We cannot easily perceive or understand the reversal of space into mass, emptiness into weight, transparency into opacity, or vice versa. The oppositions of solid and void, cast form and its mould are so fundamental that we experience severe mental difficulties and anxieties when trying to relate these inverted images. Whiteread's staircase casts create a double removal from the sense of reality. The void of the stairwell is first negated by turning it into an impenetrable mass, and then the piece is turned around its axis to violate the

paare zueinander in Beziehung zu setzen, Denk-barrieren und Ängste erleben. Whitereads Treppen entfernen uns in doppelter Hinsicht von der Realität. Der leere Raum des Treppen-hauses wird zunächst dadurch negiert, dass er in eine undurchdringlich geschlossene Form verwandelt und dann um seine eigene Achse gedreht wird, um gegen den Orientierungssinn und die Schwerkraft zu verstoßen. Diese glei-chermaßen fremdartigen und vertrauten Kon-figurationen zwingen uns dazu, mit unserem inneren Auge das ‚ungefüllte' Treppenhaus und uns selbst, die Treppen hoch- oder hinab-steigend, zu sehen. Dieser imaginierte Akt stellt unsere Welt auf den Kopf und erzeugt in uns das Gefühl, lebendig begraben zu ersticken.

Mit ihrer Schneeplastik **auf der internationa-len Ausstellung von Schnee- und Eisskulpturen im finnischen Lappland (2004) vollzog White-read eine weitere Umkehrung. Eine frühere Skulptur,** Untitled (Stairs) **von 2001, das Nega-tiv einer Treppe, verwandelte sie auch hier in ein Positiv: Der Hohlraum des Treppenhauses in ihrem Atelierhaus im Osten Londons erschien am Polarkreis zur Seite gekippt, aus glitzerndem weißem Schnee ‚gegossen', der wie Marmor wirkte.**

Bezeichnenderweise hat Whiteread erklärt, dass es ihre Absicht sei, „die Innereien eines Hauses aufzuspüren und darzustellen".[1] Auch der amerikanische Film-Semiotiker Peter Wollen gesteht Häusern eine Anatomie zu und schreibt: „Das Treppenhaus ist das symbolische Rückgrat des Hauses."[2] Genau genommen lässt sich das Treppenhaus sogar als das Herz eines Hauses bezeichnen. Es ist sein wichtigstes inneres Organ. Ständig pumpt es die Hausbewohner von oben nach unten und von unten nach oben in die Arterien und Venen der Flure, Eingangsdielen und Zimmer.

Die gegenläufige Fortbewegung auf Treppen – hinauf und hinunter – veranschaulicht gegen-

sense of orientations and gravity. These simul-taneously strange and familiar configurations force us to imagine the void shaft of the stair-well and ourselves walking up or down the steps, but this imagined act tilts our very world and eventually creates a suffocating sensation of being buried alive.

In her **snow sculpture** in the international exhibition of snow structures in Finnish Lapland (2004), Whiteread made yet another inversion. An earlier sculpture piece **Untitled (Stairs)**, 2001, the negative cast of a staircase, was once more transformed into its negative. As a consequence, the actual space of the

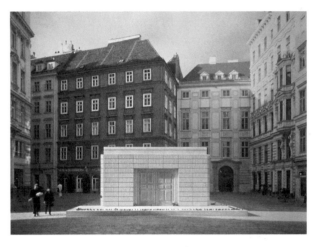

Holocaust-Mahnmal /
Holocaust Memorial
1995/2000

Mischtechnik / Mixed media
390 x 752 x 1058 cm
Wien / Vienna

staircase of her studio house in East London appeared at the Polar circle tilted on its side, cast in shimmeringly white snow, resembling solid marble.

Significantly, Whiteread has stated, that her deliberate intention is "to discover and represent the intestines of a house".[1] Acknowledging the anatomy of the house, the American film semiotist Peter Wollen writes: "Staircase is the symbolic spine of the house."[2]

sätzliche Erfahrungen und psychische Bilder. Der Aufstieg führt zum Himmel, während der Abstieg schließlich im finstern Terror der Hölle endet. Allerdings hat unsere obsessiv rationalisierte Gesellschaft ihr Gespür für derart fundamentale Gegensätze verloren. „This is really running down stairs that lead upward", schreibt Joseph Brodsky[3] und identifiziert damit die erfahrene und symbolische Asymmetrie von Treppen. Gaston Bachelard spricht von einem „umgekehrten Aufstieg".[4] Da das Bild einer Treppe Horizontalität und Vertikalität spaltet und zugleich verbindet, bildet es ein vertikales Labyrinth, welches das Angst einflößende Erlebnis von Schwindel, Absturz und Orientierungslosigkeit auslöst.

Die Denkaufgabe der Architektur besteht darin, die Vertikalität der Welt gegen die Kräfte der Erosion, des Verfalls und der Entropie zu stärken, gegen den „horizontalen Tod", wie Bachelard das schicksalhafte Ende aller Materie bezeichnet. Rachel Whitereads Treppen verwirren, die Lesbarkeit der Vertikalität wird eine doppeldeutige Angelegenheit. Sie stellen nicht nur die Autorität der Schwerkraft und der Ur-Stabilität der Erde in Frage, sondern auch die Glaubwürdigkeit unserer eigenen Wahrnehmungen. Ihre Treppen verkörpern das Reich der Absurdität und Unmöglichkeit, wie es schon M. C. Eschers, Piranesis und Jorge Luis Borges' Schwindel erregende, geometrisch nicht zu realisierende Endlos-Treppenkonstruktionen getan haben. Borges liefert eine literarisch eindrucksvolle Beschreibung dieser irreführenden Welt, in der man nicht nur die Orientierung verliert, sondern auch die Schwerkraft anzweifelt: „Er [der Palast] war voller [...] auf den Kopf gestellter Treppen, deren Stufen und Geländer nach unten hingen. Andere Treppen, die kühn aus der monumentalen Wand ragten, waren plötzlich zu Ende, ohne irgendwohin zu führen, nachdem sie in den hohen, dunklen Kuppeln zwei oder drei Kehrtwenden vollführt hatten."[5]

Even more appropriately, however, the staircase can be identified as the heart of the house. It is the most significant inner organ of a house. It keeps pumping occupants up and down into the arteries and veins of corridors, hallways and rooms.

The two opposite movements of ascending and descending a stairway represent opposite experiences and mental images; the upwards ascent is headed to Heaven, whereas the descent finally ends in the dark terror of Hell. Yet, our obsessively rationalised world has lost its sense of such fundamental differences. "This is really running down stairs that lead

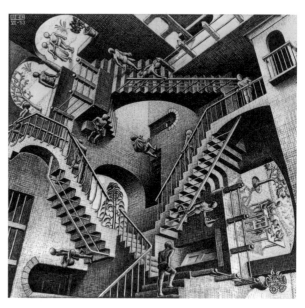

M.C. Escher
Relativität / Relativity 1953

upward,"[3] as Joseph Brodsky writes identifying the experiential and symbolic asymmetry of stairs. Bachelard writes of an "inverted ascent."[4] As the image of a stairway fragments and fuses horizontality and verticality, it turns into a vertical labyrinth that projects the disquieting experiences of vertigo, falling and getting lost.

Die Möglichkeit der Nutzung, das Versprechen der Funktion[6], ist – anders als bei anderen Kunstformen – das konstruktive Merkmal der Architektur. Und doch lebt die Baukunst auch vom natürlichen Spannungsverhältnis zwischen Zweckmäßigkeit und Nutzlosigkeit, Vernunft und Poesie, Rationalität und Metaphysik. Bei inhaltlich bedeutungsvollen Bauten geht es mehr um ihren Bezug zur Gesellschaft als um ihren rein praktischen Nutzen, und die Unterdrückung von Vernunft und Nützlichkeit scheint die metaphysische Essenz von Architektur zu offenbaren. Verfallene, eingestürzte Bauten lösen eher Erinnerungen, Melancholie und Nostalgie aus. Der Lauf der Zeiten, Abnutzung und Zerfall stärken die emotionale Wirkung architektonischer Konstruktionen, weil sie auf die Vielschichtigkeit menschlicher Lebenszeiten, Lebensgeschichten und Schicksale hinweisen.

Bröckelnde Mauern erinnern an das Schicksal der einstigen Bewohner des Hauses, und diese Erinnerungen regen unsere Fantasie an. In Rainer Maria Rilkes „Die Aufzeichnungen des Malte Laurids Brigge" führen die von Flecken und „staubigen Spuren" gezeichneten Mauern des Nachbarhauses dem Betrachter das Leben der Bewohner des zerstörten Hauses eindringlich vor Augen: „Da standen die Mittage und die Krankheiten und das Ausgeatmete und der jahrealte Rauch und der Schweiß, der unter den Schultern ausbricht und die Kleider schwer macht, und das Fade aus den Munden und der Fuselgeruch gärender Füße. Da stand das Scharfe vom Urin und das Brennen vom Ruß und grauer Kartoffeldunst und der schwere, glatte Gestank von alterndem Schmalze. Der süße, lange Geruch von vernachlässigten Säuglingen war da und der Angstgeruch der Kinder, die in die Schule gehen, und das Schwüle aus den Betten mannbarer Knaben."[7] Ein Haus als bloßer Gebrauchsgegenstand wird nie die anrührende

The mental task of architecture is to strengthen the verticality of the world against forces of erosion, decay, and entropy, "the horizontal death," as Gaston Bachelard calls the ultimate fate of all matter. Whiteread's staircases make the reading of verticality ambiguous and, consequently, they question the authority of gravity and the primal stability of the world as well as the veracity of our own perceptions. Her staircases suggest the realm of absurdity and impossibility in the manner of M. C. Escher's, Piranesi's, and Jorge Luis Borges' dizzyingly endless and geometrically impossible configurations of stairways. Borges provides a powerful literary description of this disorienting world in which not only the orientations are lost, but also gravity is cast in doubt: "It [the palace] abounded [...] incredible inverted stairways whose steps and balustrades hung downwards. Other stairways, clinging airily to the side of the monumental wall, would die without leading anywhere, after making two or three turns in the lofty darkness of the cupolas."[5]

The possibility of use – the promise of function[6] – is the constitutive quality of architecture as opposed to other art forms. Yet, there is an inherent tension between use and uselessness, reason and poetics, rationality and metaphysics in the art of building itself. Mentally meaningful buildings are more about the world than they are about their functional practicality, and suppression of reason and utility seems to reveal the metaphysical essence of architecture. Ruined and collapsed buildings project a heightened air of reminiscence, melancholy and nostalgia. Time, wear and erosion strengthen the emotive impact of architectural structures through suggestions of time, narrative and layering of human destiny.

Eroding walls remember the fate of the house's occupants and these recollections kindle our imagination. The stains and scars

Vielschichtigkeit und dramatische Intensität des vom Dichter heraufbeschworenen gelebten Lebens erreichen. Und dennoch, selbst ein Architekt wie Tadao Ando spricht vom deutlichen Spannungsverhältnis zwischen Nützlichkeit und Nutzlosigkeit in seiner Entwurfspraxis: „Ich halte viel davon, ein Bauwerk von seiner Funktion zu trennen, wenn man erst einmal die funktionalen Grundlagen beachtet hat. Anders gesagt: Ich will herausfinden, wie weit ein architektonischer Entwurf sich vom Zweck entfernen kann. Die Bedeutung der Architektur erkennt man in ihrem Abstand von ihrer Funktion."[8]

Whitereads Treppen sind keine Fantasiegebilde. Da sie dem wirklichen Leben entnommen sind, besitzen sie eine gewissermaßen lakonische Ausstrahlung und die Glaubwürdigkeit des Realen. Realität ist nicht immer wahrscheinlich, äußert sich Borges sinngemäß zum Grundbedürfnis des Menschen nach Wirklichkeit und Wahrheit in der Literatur, wenn man aber eine Geschichte schreibe, müsse man sie so plausibel wie möglich gestalten, sonst werde die Einbildungskraft des Lesers sich gegen sie sträuben.[9] Das gilt mit Sicherheit auch für Architektur und Plastik. Kunstwerke, die nicht in gelebter menschlicher Realität verwurzelt sind, bleiben unweigerlich leere Dekorationen.

Sigmund Freud und Carl Gustav Jung sowie zahlreiche Künstler in Vergangenheit und Gegenwart haben auf die enge Verbindung von menschlichem Körper und menschlicher Behausung hingewiesen. Wir sehen unsere Häuser als Körper und unsere Körper als unsere Behausung. Tatsächlich steckt hinter allen Wahrnehmungsprozessen die unbewusste Projektion von Ich-Anteilen auf das Wahrgenommene. In einer seiner berühmten Traumdeutungen beschreibt Jung die Identifizierung des Ich mit den verschiedenen Etagen und Treppen des Traumhauses und die vielschichtige Historizität

left on the wall of the neighbouring house in Rainer Maria Rilke's "The Notebooks of Malte Laurids Brigge" vividly expose the lives lived in the rooms of the already demolished house: "There stood the middays and the sicknesses and the exhaled breath and the smoke of years, and the sweat that breaks out under armpits and makes clothes heavy, and the stale breath of mouths, and the fusel odor of sweltering feet. There stood the tang of urine and the burn of soot and the grey reek of potatoes, and the heavy, smooth stench of ageing grease. The sweet, lingering smell of neglected infants was there, and the fear-smell of children who go to school, and the sultriness out of the beds of nubile youths."[7]

A house as a mere instrument of utility can never achieve this touching layering and dramatic intensity of the poet's invocation of lived life. However, even one of today's architects, Tadao Ando, speaks of a distinct tension between usefulness and uselessness in his design process: "I believe in removing architecture from function after ensuring the observation of functional basis. In other words, I like to see how far architecture can be removed from function. The significance of architecture is found in the distance between it and function."[8]

Whiteread's staircases are not arbitrary inventions or fabrications. They have been generated by actual structures of real life, and this process grants them a laconic radiance and the authority of the real. "Reality is not always probable or likely. But if you are writing a story, you have to make it as plausible as you can because otherwise the reader's imagination will reject it," writes Borges of the essential need for a sense of reality and truth in the art of literature.[9] The same requirement for a sense of the real surely applies to the arts of architecture and sculpture. Artistic works that are

des menschlichen Denkens. Der Träumer findet sich im Obergeschoss eines Hauses in einem mit eleganten Rokoko-Möbeln ausgestatteten Salon. Er steigt die Treppe hinunter und gelangt ins Erdgeschoss mit mittelalterlicher Einrichtung. Hinter einer massiven Tür entdeckt er die Kellertreppe. Das Kellergewölbe datiert offenbar aus römischer Zeit. Der Boden ist mit großen Steinplatten belegt, eine davon mit einem Metallring versehen. Der Träumende hebt die Platte hoch und sieht eine schmale Steintreppe, die ihn in eine niedrige Felsenhöhle führt, auf deren staubbedecktem Boden er Knochen und Tonscherben verstreut findet, die ihm wie die Überreste einer primitiven Zivilisation erscheinen.[10]

Rachel Whitereads Formen vermitteln eine ähnlich archetypische Geschichtlichkeit architektonischer Bilder. Ihre Abgüsse sind baukünstlerische Fossilien, die das Abbild eines Raums in der gleichen Weise ‚mumifizieren', wie es geologische Prozesse mit primitiven Lebewesen aus grauer Vorzeit getan haben oder wie die erstarrte Lava in Pompeji und Herculaneum Momentaufnahmen der Tragödie des Vesuv-Ausbruchs verewigte. Whitereads ebenfalls versteinerte, verewigte Objekte und Räume projizieren Fantasien des Lebens und Bilder des Todes. Zugleich erinnern uns ihre Treppen an zahlreiche Treppen aus der Kunstgeschichte: von Tizians Tempelgang Mariae bis hin zu Eadweard Muybridges Fotostudien von Frauen, die Treppen hinunter steigen, oder Marcel Duchamps Gemälde Weiblicher Akt, eine Treppe hinabsteigend.

Whitereads Werken – vom begehbaren Schrank über Abgüsse von Matratzen, Betten, Stühlen, Tischen, Badewannen und Türen bis zu Räumen, Treppen und schließlich einem ganzen Haus – liegt das Maß des menschlichen Körpers zugrunde. Ihre Arbeiten beschwören die Präsenz des menschlichen Körpers in ver-

not rooted in lived human reality are doomed to remain mere empty decorations.

Sigmund Freud and Carl Gustav Jung, as well as numerous artists through history, have revealed the strong mental association between the body and the house; we imagine houses as our bodies and our bodies as houses. In fact, an unconscious projection of fragments of Self is concealed in all processes of perception. In a famous description of a dream of his, Jung gives an example of the identification between Self and the various storeys and stairways of the oneiric house, and of the layered historicity of the human mind itself. The writer finds himself on the upper storey of a house, in a salon furnished with pieces of fine old rococo furniture. Descending the stairs, he reaches the ground floor where the furnishings are medieval. Behind a heavy door, he discovers a stairway leading down into the cellar. The vaulted cellar apparently dates from Roman times. The floor is made of stone slabs, one of which is provided with a ring. Lifting the stone slab, the dreamer finds a stairway of narrow stone steps, which leads him to a low cave cut into rock. Scattered on the dust-covered floor, like the remains of a primitive culture, are bones and broken pottery.[10]

Whiteread's casts project a similar archetypal historicity of architectural images. Her pieces are architectural fossils which embalm the image of a space in the same manner as geological processes have eternalised images of primordial life, and petrified lava halted passing moments of the tragedies of Pompeii and Herculaneum. Rachel Whiteread's petrified and immortalised objects and spaces project simultaneously fantasies of life and images of death. At the same time, her staircases remind us of numerous stairways in the history of art from Titian's **The Presentation of the Virgin** to Eadweard Muybridge's photographic studies

schiedenen Positionen und Bewegungen. Tür, Bett, Stuhl, Badewanne und Treppe sind die architektonischen Elemente, mit denen wir körperlich aufs Engste in Berührung kommen und die wir in der Begegnung ‚abmessen'. Mit Badewanne und Bett haben wir vor allem Hautkontakt; der Stuhl bildet unsere sitzende Körperhaltung ab, die Treppe unsere Körper in Bewegung, während der Raum vom Akt des Wohnens zeugt.

Die Treppe bringt uns in intensiven physischen Kontakt mit dem Gebäude und seinem Raum: Der Fuß misst die Tiefe der Trittstufe, die Wade streift die Setzstufe, die Hand folgt dem Handlauf und der Körper bewegt sich vertikal-diagonal durch den Raum. Die gedachte Bewegung belebt die Architektur und verwandelt die Treppe in ein animistisches Bild. Ihre Drehungen und Windungen ähneln der einer Schlange, ein Bild, das sich in Rachel Whiterads architektonischen Analysen deutlich widerspiegelt. Ihre ‚Stein gewordenen' Treppenhäuser wirken aber auch wie anatomische Exponate, wie Beispiele konstruierter Stoffwechselvorgänge oder Fragmente einer architektonischen Kreatur. Beim Anblick der fragmentierten Abgüsse tektonischer Organe muss der Betrachter unwillkürlich das ganze Gebäude als Organismus auffassen. Die Umkehrung der Leere in Masse verwandelt das ‚immaterielle', imaginierte Treppenhaus auch in ein provokantes phallisches Symbol. Tatsächlich assoziierte Freud das Begehen einer Treppe mit dem Geschlechtsakt. Andererseits verweist das Hinauf- oder Hinabsteigen auch auf eine dem Geschlecht zugeordnete Lesart, wobei das Hinaufsteigen mit dem Männlichen, das Herabsteigen mit dem Weiblichen konnotiert wird.

Rilke beschreibt das Fragmentarische der Erinnerung an ein Haus in einer Weise, die auf die Art hindeutet, in der Rachel Whiteread mit ihren Werken versucht, uns die verlorene architektonische Ganzheit vor Augen zu führen: „Ich

of women descending stairs, and Marcel Duchamp's painting **Nude Descending a Stair**.

From her intimate interior of a closet and casts of mattresses, beds, chairs, tables, bathtubs and doors to casts of rooms, staircases and, finally, an entire house, the unifying measure of all Whiteread's pieces is the human body. The pieces evoke the intimate presence of the body in its various positions and acts. The door, bed, chair, bathtub and staircase are the architectural elements which we confront most directly with our bodies and which we also 'measure' through this physical encounter. The bath and the bed address the skin, the chair reflects body postures, the staircase evokes body movements, whereas the room speaks of the act of inhabitation.

The staircase puts us in an intensely physical contact with the building and its space; the foot measures the width of the step, the leg encounters the riser, the hand follows the handrail, and the body moves diagonally across space. The imagined movement animates geometry and turns the staircase into an animistic image. Its twisting and tossing around itself projects a serpent-like image, that is clearly reflected in Whiteread's architectural dissections. Her petrified stairwells also appear as anatomic exhibits, samples of a constructed metabolism, or fragments of an architectural creature. These fragmented casts of tectonic organs make the viewer think of the entire building as an organism. The reversal of void into solid also turns the immaterial stairwell into a provocatively phallic image. In fact, Freud associates the act of ascending stairs with copulation. On the other hand, ascending and descending stairs suggest a gender reading; the first evokes male, the latter female connotations.

Rilke describes the fragmentation of the memorised image of a house in a manner that suggests the way that Rachel Whiteread's

habe das merkwürdige Haus später nie wiedergesehen […] So wie ich es […] wiederfinde, ist es kein Gebäude; es ist ganz aufgeteilt in mir; da ein Raum, dort ein Raum und hier ein Stück Gang, das diese beiden Räume nicht verbindet, sondern für sich, als Fragment, aufbewahrt ist. In dieser Weise ist alles in mir verstreut, – die Zimmer, die Treppen, die mit so großer Umständlichkeit sich niederließen, und andere enge, rundgebaute Stiegen, in deren Dunkel man ging wie das Blut in den Adern; […] – alles das ist noch in mir und wird nie aufhören, in mir zu sein. Es ist, als wäre das Bild dieses Hauses aus unendlicher Höhe in mich hineingestürzt und auf meinem Grunde zerschlagen."[11]

Gebäude schaffen, bewahren und beschützen Räume der Stille. Große architektonische Räume sind langmütige Befestigungswerke und Museen der Ruhe. Rachel Whitereads architektonische Gussstücke sind versteinerte Geräuschlosigkeit. Wie sie selbst sagt, will sie „die Anmutung von Stille in einem Raum mumifizieren".[12] Ihre Skulpturen beschwören erhabene Schönheit und architektonischen Schrecken, ebenso Masse und Leere, Dunkelheit und Licht als die gegensätzlichen Pole ihres Erlebens. Louis I. Kahn, der nicht nur Archetypen und Urerfahrungen, sondern auch die Aura der Geometrie und der Schwerkraft wieder in die zeitgenössische Architekturphilosophie einführte, pflegte zu sagen: „Materie ist verbrauchtes Licht."[13] Rachel Whitereads Bilderwelt verwandelt das Licht des Raumes in die Dunkelheit der Materie. Mit ihren Skulpturen ‚verbraucht' sie beides: Licht und Raum. Ungeachtet ihrer zumeist strahlend weißen Farbe bilden ihre Treppen Räume von undurchdringlicher, ewiger Dunkelheit ab.

Die Aufeinandertreffen von Peter Zumthors in Beton gegossenem Kunsthaus in Bregenz und Rachel Whitereads ‚verkehrten' Gussstücken ist einzigartig und provokativ. Der architektonische Raum stellt die Umkehrung seiner massiven

fragmentations make us attempt to imagine the lost architectural entity: "Afterwards I never again saw that remarkable house […] it is no complete building: it is all broken up inside me; here a room, there a room, and here a piece of hallway that does not connect these two rooms but is preserved, as a fragment, by itself. In this way it is all dispersed within me. The rooms, the stairway that descended with such ceremonious deliberation, and other narrow, spiral stairs in the obscurity of which one moved as blood does in the veins […] all that is still in me and will never cease to be in me. It is as though the picture of the house had fallen into me from an infinite height and has shattered against my very ground."[11]

Buildings create, maintain and protect silence; great architectural spaces are patient fortifications and museums of tranquility. Whiteread's architectural casts fossilise silence. In her own words, she aspires to "mummify the sense of silence in a room".[12] These images simultaneously invoke a sense of sublime beauty and architectural terror. Matter and void, darkness and light are primal experiential oppositions. Louis I. Kahn, the architect who re-introduced archetypes and primordial experiences, as well as the aura of geometry and gravitas, to contemporary architectural thought often said: "Matter is spent light."[13] Whiteread's images turn the light of space into the obscurity of matter; both light and space are 'spent' in her sculpting process. Regardless of their mostly glowing whiteness her stairway casts portray spaces of impenetrable opacity and eternal darkness.

The juxtaposition of Peter Zumthor's architecture of the Kunsthaus in Bregenz, cast in concrete, and Rachel Whiteread's inverted sculptural casts is unique and provocative. The architectural space is an inversion of its solid formwork into space, whereas the

Form im Außenraum dar, während die ausgestellten Skulpturen Ergebnisse des umgekehrten Arbeitsvorgangs sind. Die Plastiken reflektieren Spiegelbilder des architektonischen Raumes. Die Ausstellungshallen und Treppen, fugenlos in einem einzigen Arbeitsgang gegossen, zeugen von einmaliger Festigkeit. Das Gebäude ist in Wirklichkeit eine Höhle – wie aus einem einzigen Betonfelsblock herausgemeißelt. „Die Eigenschaften der Gußmasse Beton, in komplexe Formen zu fließen [...] und schließlich eine monolithische Großform von annähernd skulpturalem Charakter zu bilden, werden dabei voll ausgeschöpft."[14] Damit beschreibt Zumthor seine Entwurfsintentionen für das Kunsthaus, er könnte aber ebenso gut Rachel Whitereads bildhauerisches Schaffen charakterisiert haben. Die mit großer Präzision ausgeführten Gussstücke der Künstlerin vermitteln die gleiche Entschlossenheit im gleichen Bemühen um absolute Perfektion. Die architektonischen Darstellungswelten der Bildhauerin und des Architekten, in dessen Bau sie ausstellt, wollen beide den Lärm der Welt zum Schweigen bringen und zu Begegnungen mit einer Stein gewordenen Stille einladen.

exhibited sculptures result from reverse processes; sculpture projects mirror images of architectural space. The exhibition halls and stairways, cast as a single pour without working seams, evoke a singular solidity; the building is essentially a cave, as if sculpted from a solid mass of concrete. "The ability of the cast concrete to flow into complex shapes [...] and to assume the appearance of a large monolithic form of an almost sculptural character has been fully exploited,"[14] Zumthor describes his architectural intention as if he were describing the genesis of Whiteread's sculpture.

Rachel Whiteread's meticulously executed casts exhibit the same determination and quest for painstaking perfection. The architectural imageries of the sculptor as well as the architect of the exhibition space aspire to silence the clatter of the world into encounters with petrified silence.

Peter Zumthor
Kunsthaus Bregenz 1997
Ansicht Treppenhaus / Staircase
Foto / Photo Hélène Binet

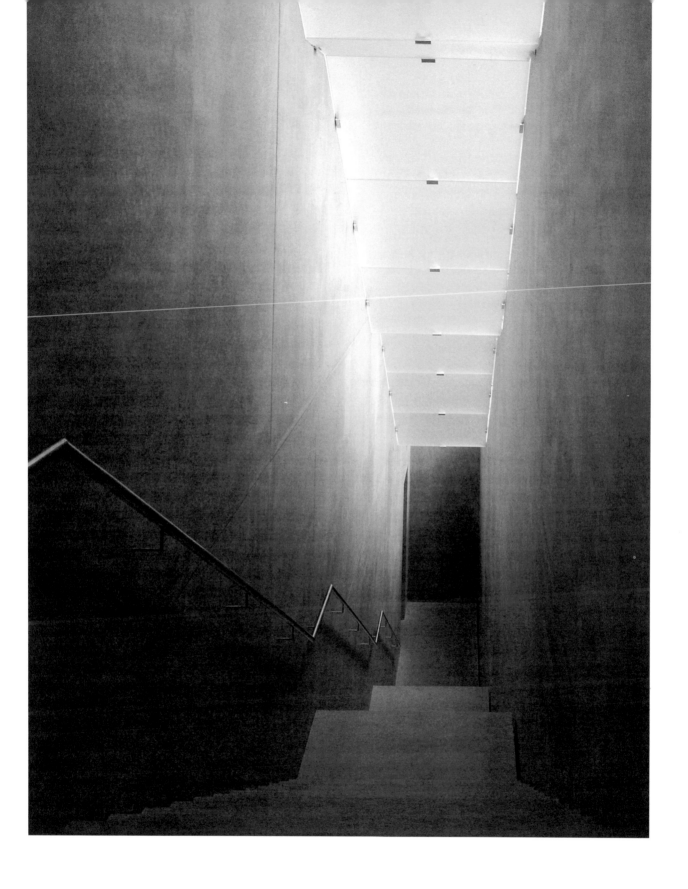

1 Rachel Whiteread in conversation with Iwona Blazwick, Stedelijk Van Abbemuseum, Eindhoven 1992, S. 9.

2 Peter Wollen, ‚Arkkitehtuuri ja elokuva: paikat ja epäpaikat [Architektur und Film: Orte und Nicht-Orte]', in: Rakennustaiteen seura, jäsentiedote 4, Helsinki 1996, S. 15.

3 Joseph Brodsky, ‚On Grief and Reason', in: ders., On Grief and Reason, New York 1995, S. 250 (deutsche Ausg. Von Schmerz und Vernunft, München 1996).

4 Gaston Bachelard, L'air et les songes: essai sur l'imagination du mouvement, Paris 1943 (hier zitiert / übersetzt nach: Air and Dreams: An Essay on the Imagination of Movement, Dallas 1988, S. 15).

5 Vgl. Jorge Luis Borges, ‚Der Unsterbliche', in: ders., Der Zahir und andere Erzählungen, Frankfurt/M. 1964 (Zitat hier übersetzt nach: ‚The Immortal', in: Labyrinths, London 1970, S. 141).

6 Mitte des 19. Jahrhunderts bezeichnete der amerikanische Bildhauer Horatio Greenough mit dieser Formulierung zum ersten Mal die wechselseitige Abhängigkeit von Form und Funktion, die später zum dogmatischen Eckstein der Neuen Sachlichkeit (des Funktionalismus) wurde. Vgl. Harold A. Small (Hg.), Horatio Greenough, Form and Function. Remarks on Art, Design and Architecture, Berkeley–Los Angeles 1966.

7 Rainer Maria Rilke, Die Aufzeichnungen des Malte Laurids Brigge, Erstdruck: Leipzig 1910 (hier zitiert nach: Stuttgart 1997, S. 43).

8 Tadao Ando, ‚The Emotionality Made Architectural Spaces of Tadao Ando', in: The Japan Architect, April 1980, S. 45f.

9 Norman Thomas di Giovanni, Daniel Halpern und Frank MacShane, Borges on Writing, Hopewell (NJ) 1994, S. 45.

10 Vgl. C. G. Jung, Erinnerungen, Träume, Gedanken, aufgez. u. hg. von Aniela Jaffé, 13. Aufl., Olten 1988, Kap. V: Sigmund Freud.

11 Rilke, wie Anm. 7, S. 24f.

12 Iain Gale und Dalya Alberge, ‚Youth and Beauty', in: The Independent (16.7.1991), S. 17.

13 Louis I. Kahn, ‚Architecture', in: Louis I. Kahn, Writings, Lectures, Interviews, hg. von Alessandra Latour, New York 1991, S. 273.

14 Peter Zumthor, ‚Kunsthaus Bregenz', in: Peter Zumthor, Kunsthaus Bregenz, hg. vom Kunsthaus Bregenz, archiv kunst architektur, Werkdokumente (12), Ostfildern-Ruit 1997, S. 7.

1 'Rachel Whiteread in conversation with Iwona Blazwick' (Eindhoven: Stedelijk Van Abbemuseum, 1992), p. 9.

2 Peter Wollen, 'Arkkitehtuuri ja elokuva: paikat ja epäpaikat' (Architecture and cinema: places and non-places), Rakennustaiteen seura, jäsentiedote (Helsinki), 4 (1996), p. 15.

3 Joseph Brodsky, 'On Grief and Reason,' in: On Grief and Reason (New York: Farrar, Straus and Giroux, 1995), p. 250.

4 Gaston Bachelard, Air and Dreams: An Essay on the Imagination of Movement (Dallas: The Dallas Institute Publications, 1988), p. 15.

5 Jorge Luis Borges, 'The Immortal,' in: Labyrinths (London: Penguin Books, 1970), p. 141.

6 In the mid-19th century, the American sculptor Horatio Greenough gave with this notion the first formulation on the interdependence of form and function, which later became the ideological corner stone of Functionalism. Horatio Greenough, Form and Function: Remarks on Art, Design and Architecture, edited by Harold A. Small (Berkeley and Los Angeles: University of California Press, 1966).

7 Rainer Maria Rilke, The Notebooks of Malte Laurids Brigge, trans. M. D. Herter Norton (New York and London: W. W. Norton & Co., 1992), p. 47–48.

8 Tadao Ando, 'The Emotionality Made Architectural Spaces of Tadao Ando,' in: The Japan Architect (April 1980), p. 45–46.

9 Borges on Writing, edited by Norman Thomas di Giovanni, Daniel Halpern and Frank MacShane (Hopewell, New Jersey: The Ecco Press, 1994), p. 45.

10 C. G. Jung, Memories, Dreams, Reflections, edited by Aniela Jaffé (New York: Vintage Books, 1989), Chapter V: Sigmund Freud, p. 158f.

11 Rilke, The Notebooks of Malte Laurids Brigge, op. cit., p. 30–31.

12 Iain Gale and Dalya Alberge, 'Youth and Beauty,' in: The Independent (16 July 1991), p. 17.

13 Louis I. Kahn, 'Architecture,' in: Louis I. Kahn: Writings, Lectures, Interviews, edited by Alessandra Latour (New York: Rizzoli International Publications, 1991), p. 273.

14 Peter Zumthor, 'Kunsthaus Bregenz,' in Peter Zumthor – Kunsthaus Bregenz, edited by Kunsthaus Bregenz archiv kunst architektur. Werkdokumente (12) (Ostfildern-Ruit: Hatje, 1997), p. 13.

Untitled (Upstairs) 2000/2001
Mischtechnik / Mixed media
550 x 330 x 570 cm
Courtesy of the artist and Gagosian Gallery

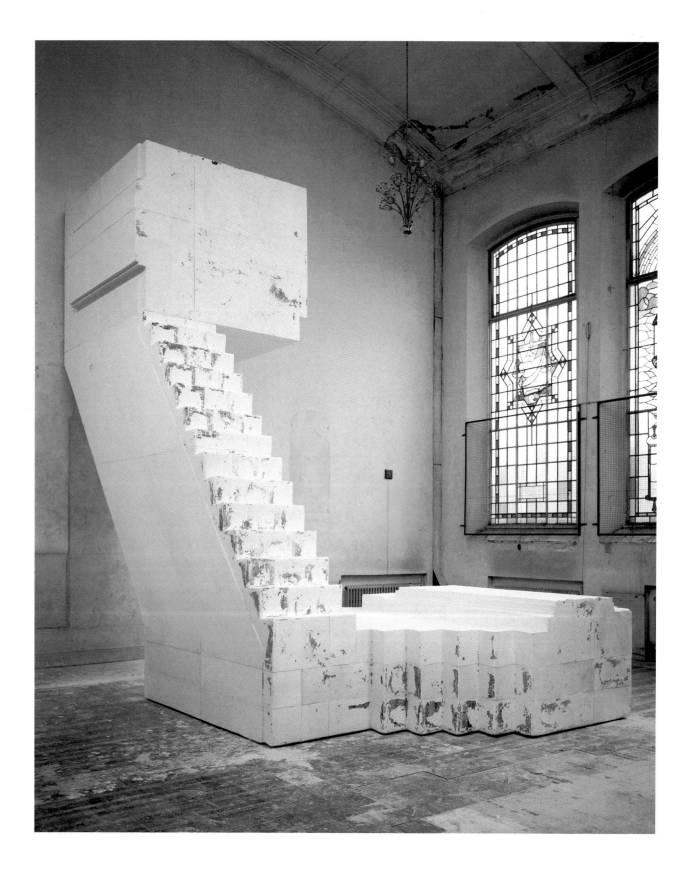

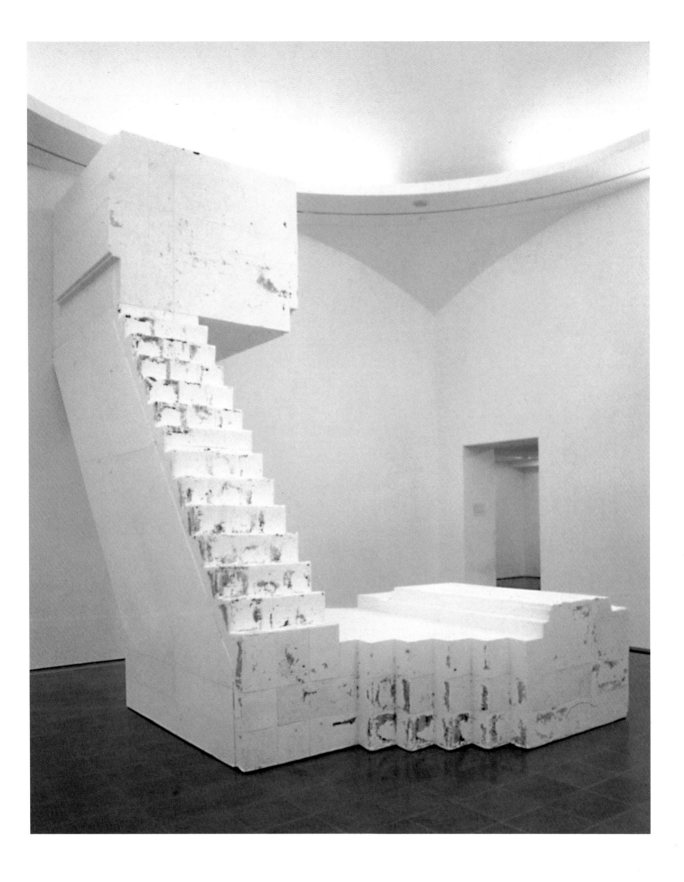

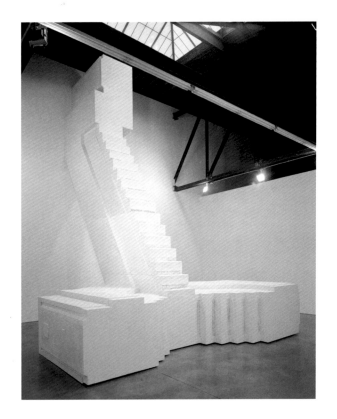

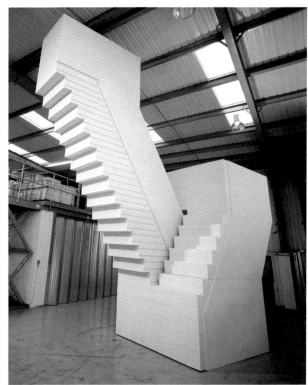

Untitled (Fire Escape) 2002
Mischtechnik / Mixed media
736 x 547 x 600,5 cm

Untitled (Domestic) 2002
Mischtechnik / Mixed media
676 x 584 x 245 cm

Floor Pieces

Die Welt ist die Gesamtheit der Tatsachen, nicht der Dinge.

Mario Codognato

Ludwig Wittgenstein

Die Dinge, die uns umgeben, die dieses nicht definierbare Magma bilden, das wir als alltäglich bezeichnen, sie sprechen, sie agieren und sie absorbieren unsere Aufmerksamkeit oder Gleichgültigkeit und auch unsere Zeit und unseren Widerstand gegen sie. Sie nehmen den soziopolitischen Kontext, der sie produziert hat, sowie die Arbeit und den Geist, die sie hervorgebracht haben, in sich auf; das Verführerische steckt in ihrer Körperhaftigkeit. Sie stellen eine Metasprache dar, und sie bilden und reflektieren in einer unerschöpflichen Verknüpfung von Bezügen eine persönliche und kollektive Mythologie, die nicht nur unsere existenziellen und individuellen Erfahrungen, sondern auch die Mechanismen der Geschichte und die zwischenmenschlichen Beziehungen verändert. Die neuen bzw. noch unberührten Dinge glänzen in ihrer Aura der Verfügbarkeit und Unversehrtheit, sie zelebrieren den Mythos des Wohlstands und der Industriegesellschaft. Die benutzten Dinge hingegen leuchten in ihrer Aura des Gelebten und der Personalisierung, sie zelebrieren den Mythos der Vergangenheit und der Geschichte.

In der Kunst der Gegenwart bewahren die Gegenstände – seit des Readymades von Duchamp und dem Dadaismus – absichtlich Spuren von ihrem anfänglichen Zweck, auch wenn sie dem ursprünglichen Kontext entzogen und in den einer Ausstellung eingefügt werden. Gleichzeitig rechtfertigen sie ihre Existenz durch neue Bedeutungen und kritische Inhalte. Sie überwinden die ausgeprägte Eitelkeit und die verpflichtende Territorialität der Mimesis zugunsten einer Leseweise, die zwischen Wortlaut und Metapher eine doppelte Realität her-

The World Is the Totality of Facts, Not of Things.

Mario Codognato

Ludwig Wittgenstein

The objects that surround us, forming that indefinite and indefinable magma to which we refer as daily life, speak of, take part in, and absorb not only our attention or indifference, but as well the wear and tear of time and their own resistance to it, the socio-political context that produced them, the labour and inventiveness which forged them, the seduction of their bodily presence. They constitute a metalanguage: with endless chains of interlocking references, they evoke and reflect a personal and collective mythology that holds not only the saga of our own individual existence, but as well the mechanisms of history and of relationships between individuals. New, virginal objects glow with an aura of potential and wholeness, and celebrate the myth of prosperity and industrial civilisation. Used objects glow with an aura of past experience and personalization, and celebrate the myth of the past and of history.

In the art of our time – hailing back to the indispensable Duchampian and Dada tradition of the Ready-made – objects removed from their original settings and inserted into contexts of exhibition deliberately maintain a trace of their initial functions while at the very same time exercising a legitimate right to the assumption of new meanings and the expression of critical content. They go beyond the virtuosic vanity and coercive territoriality of mimesis in favour of a reading, no less textual than metaphoric, which creates and reconstructs a double reality, revitalised by the context of art, in which they preserve their origins in the world of the utilitarian while also conti-

vorbringt bzw. nachbildet, welche durch den Kunstkontext neu belebt wird. Dabei bleibt die ursprüngliche utilitaristische Wurzel eines Gegenstands zwar erhalten, jedoch wird diese abgewandelt und durch eine sorgfältig gesteuerte Präsentation mit neuen Inhalten aufgeladen: Entscheidend sind dabei die Anordnung, die Verknüpfung mit anderen Elementen, die Serialität, die sprachliche und morphologische Mehrdeutigkeit.

Im Werk von Rachel Whiteread lassen die Gegenstände in vielseitigen Anspielungen und semantischen Konstrukten die Gestalt und Komplexität ihrer Existenz hinter sich, indem sie den idealen Ort und die Luft, die sie umgibt oder die sich in ihnen befindet, materialisieren. Etwas Magisches, eine Hyperbel, ein Paradox entsteht, das im Umfeld des Readymades von neuem einer skulpturalen Praxis folgt. Das erweckt die Vorstellung von Verwandlung, der Inbesitznahme eines autonomen und unbekannten Raumes, die das Negative in das Positive, das Unfeste in das Feste, das Innere in das Äußere, das Hohle in das Gefüllte umwandelt. Die Dinge scheinen wie vom Raum absorbiert zu sein, sie hinterlassen im Abguss der Leere, die sie umgibt, eine Spur von ihrer Präsenz und Existenz. Sie lassen ihre wörtliche Bedeutung zurück, um zu einer autonomen Form zu werden, einem Simulacrum (R. Barthes) und Änigma. Sie bewahren das Wesenhafte und erheben sich zugleich zu einer neuen Autorität und Selbstgenügsamkeit, indem sie eine mnemonische Kettenreaktion auslösen, die einen materiellen Prozess (die Entstehung aus einem vorher vorhandenen Modell) und einen sinnlichen Prozess (die neue Substanz und Beschaffenheit) zusammenführt. Dabei vollzieht sich ein Reinigungsprozess, durch den der Gegenstand seine nützliche Banalität und individuelle Geschichte zu einem kritischen Modell des heutigen urbanen Lebens und seiner Widersprüche

nuing to sound them, recharging themselves with new content by way of the control of their presentation and positioning, their juxtaposition to other elements, their seriality, their linguistic and morphological ambiguity.

Objects in the work of Rachel Whiteread are marked by a polyhedral irradiation of allusions and semantic constructs, casting their shadows and outlining their complex identities by way of the materialisation of the ideal territory of the air which surrounds or lies inside them. A form of magic, an hyperbole, a paradox that reconciles the notion of the Ready-made with the praxis of sculpture, with the evocation of transmutations, with an occupation of autonomous and unknown spaces where the negative finds itself transformed into the positive, emptiness into solidity, cavities into sculptural form. Objects, here, leaving a trace of their presence and existence in casts of the void that surrounds them, seem to be absorbed by space. They abandon their factuality and turn instead into autonomous form and history, simulacrum and enigma. They retain their essence while at the same time acquiring a new authority and a self-sufficiency, giving life to mnemonic chain reactions that reconstruct a material past (their realisation on the basis of a pre-existent model) as well as a process of sensorial becoming (the new substance in which they're reproduced) while as well embarking on a route of purification that elevates the object, releasing it from banality as an object of use with a meagre individual history, and turning it instead into a critical model of contemporary urban life and the self-contradictions that belong to it. Frequently retrieved from domestic objects (a bed, a table, a chair, a bathtub, a door, a ladder ...) Whiteread's sculptures lead the mind back to a human scale through a subtle no less than sophisticated anthropomorphism of absence where the residues of bodies

erhebt. Häufig entstehen die Skulpturen von Rachel Whiteread aus alltäglichen Dingen (Bett, Tisch, Stuhl, Badewanne, Tür, Treppe ...), und sie lenken die Gedanken auf die menschlichen Verhältnisse, auf einen ausgeklügelten und subtilen Anthropomorphismus der Abwesenheit: Die Spuren des Körpers hinterlassen einen Abdruck von der eigenen Vergänglichkeit, und die Materialisierung des Raumes verstärkt in den Gegenständen und um sie herum die Erfahrung einer existenziellen Klaustrophobie, ausgelöst von den geringen Handlungsspielräumen innerhalb der sozialen Beziehungen. Die Welt wird durch diese greifbare Beziehung von Leere und Fülle, die von den Möglichkeiten und Selbstbezügen der Kommunikationsmedien infolge der raum-zeitlichen Verschiebung der Wahrnehmung aufgehoben wird, wieder zusammengesetzt und sichtbar gemacht. Diese Verdrehung und die Umwandlung von Leere in Fülle zeigt sich in der Materialität, in der Schwerkraft, im Gewicht, in der physischen Wirklichkeit, und zugleich verdeutlicht sie die Möglichkeiten der Imagination, der poetischen Suggestion, der Fähigkeit, die Realität durch die Verfahren und die Arbeit der Kunst zu sublimieren und transformieren.

Die Architektur ist ihrerseits der Spiegel und das materielle Gewissen der Menschheit. So ist es möglich, aus der Dokumentation und kritischen Analyse der vom Menschen bebauten Umwelt die gesellschaftliche Ordnung einer bestimmten Zivilisation zu einem bestimmten historischen Zeitpunkt zu rekonstruieren. Die Architektur ordnet die hierarchischen Aufgaben und produktiven Aktivitäten einer Gesellschaft und verteilt sie in derselben, sie verdeutlicht die herausragende Rolle eines Einzelnen, einer Gruppe, der Spezies, und gleichzeitig lenkt und beeinflusst sie auf einschneidende Weise unsere Art zu leben, zu denken und mit uns selbst oder anderen zu kommunizieren. Die Objekti-

leave behind a cast of their perishability, and where the materialisation of the spaces within or around them intensifies the sense of existential claustrophobia that derives from the narrowness of the margin for manoeuvre in social relationships. The world is reconstructed and investigated by way of a tangible relationship of full and empty spaces which the relentless virtuality and self-referentiality of the means of communication render light and heady by way of their spatio-temporal disalignment of perceptions. The reversal of full and empty, and the alternation between them signal the materiality, the gravitational attraction, the weight, the physicality of the real while at the same time revealing the power of imagination, of lyrical suggestion, of the capacity for the sublimation and transformation of reality by way of the process of art.

Architecture, in turn, is the mirror and material consciousness of human life. The documentation and critical analysis of the spaces built by human beings make it possible to reconstruct the aspirations and social order of a given civilisation in a given historical moment. Architecture orders and apportions the hierarchical functions and productive activities of a society, expresses the genius of an individual, of a group, of the species, and at the same time channels and profoundly influences our ways of life, of thinking, of relating to ourselves and others. The objectification and exegesis of architecture by way of the making of casts of the empty spaces in the interior of a building (a room, a house), or by way of the doubling or reconstruction of a preexistent structure in another material (the monumental plinth at the centre of a public square, a watertower) draws attention – paradoxically so, through a concretisation of the invisible – to the sedimentation of the signs of history, of political life, of creativity, and of the

vierung und Deutung der Architektur aus dem Abdruck des leeren Raumes innerhalb eines Gebäudes (eines Zimmers, eines Hauses) oder die Verdopplung bzw. Wiederherstellung eines vorher vorhandenen Elements in einem anderen Material (ein monumentaler Sockel auf einem Platz, ein Wasserturm) verdeutlichen – paradoxerweise durch die Konkretisierung des Unsichtbaren – die darin kondensierten Zeichen aus der Geschichte, der Politik, der Kreativität des menschlichen Daseins. Demnach entsteht ein Gegen-Ambiente, das die Struktur des Ursprungsmodells wiederholt, allerdings in der Gegenrichtung, im Negativ, und es verschiebt

general human landscape. It's a question of the construction of a counter-environment that recapitulates – as though in reverse, as though in negative – the structure of the original model, shifting attention from the ordinary to the exceptional: to the exceptionality of a context that absorbs and regenerates everything.

Floors – the architectural reformulation of traversing a space – lie both plastically and visually at a mid-way point between sculpture and architecture. The floor delimits a territory which both the eye and the body can enter and explore. The dynamic it materialises is both gravitational and fluid. It involves and speaks

Rachel Whiteread
Water Tower 1998
West Broadway / Grand Street, New York
Harz und Stahl / Resin and steel
340,4 x 243,8 cm

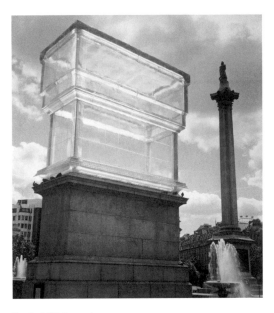

Rachel Whiteread
Monument Trafalgar Square 2001
London
Gießharz / Cast resin
4,5 x 5,1 x 2,4 m

die Aufmerksamkeit für das Gewöhnliche zu jener für das Außergewöhnliche des Kontextes, der alles aufsaugt und bestimmt.

Der Fußboden als architektonische Umsetzung, um einen Raum durchschreiten zu können, steht plastisch und visuell auf halbem Weg zwischen Skulptur und Architektur. Er

of the horizontality of moving across it, and it likewise speaks of the vertical constraints, the perimeter, of the room that contains it. It holds traces of the passing of time, and a record of the weight of the feet which have walked across it. It is slowly but inevitably worn away by the shifting, nervous patterns of the feet that strike

begrenzt eine mit Augen und Körper begehbare Fläche. Er verkörpert zugleich eine Dynamik zwischen Gravitation und Flüchtigkeit. Der Boden führt das Horizontale der Bewegung mit der vertikalen Kraft des Raumes, der sie umschließt, zusammen. Er nimmt die Spuren der Zeit und die Last der Schritte auf. Langsam und unaufhaltsam wird er von der trockenen und ungleichen Reibung der Schritte abgeschliffen, die Wege und Gewohnheiten der Bewohner werden absorbiert und prägen sich ihm ein. Der Boden verdeutlicht und veranschaulicht eine Dichotomie zwischen dem Transitorischen des Lebens und der Dauerhaftigkeit einer leblos gewordenen Welt: Generationen haben und werden ihn betreten, unter den geschichtlichen Veränderungen, die sie begleiten. Der Boden trägt die Bühne der „comédie humaine", er lässt die Inhalte des Körpers gerinnen, sowohl die materielle als auch die produktive und vorausgerichtete Agilität der Bewegung und Aktion.

Der Boden weckt die Erinnerung an die Mühen der weiblichen Hausarbeit und die gekrümmten Rücken bei seiner Reinigung. Im Werk von Rachel Whiteread stellen die Fußböden eine visuelle und konzeptuelle Synthese der komplexen und vielschichtigen Dynamik von Anregungen dar, die sich an den Betrachter richtet. Sie sind ein autonomes Subjekt und gleichzeitig die negative Kopie von einer schon vorher existierenden politisch wie sozial dichten Sache. Sie sind Skulptur und Architektur zugleich. Durch den physischen Kontakt, die Möglichkeit, sie zu betreten, darauf in alle Richtungen gehen zu können, setzen sie einen Wahrnehmungsmechanismus in Gang, der den Betrachter sowohl in Raum und Zeit involviert. Diese durch Schwerkraft und Sinneswahrnehmung gelenkte Interaktion ist grundlegend und ein Bestandteil des Werkes selbst. Die Künstlerin betrachtet daher das Werk für niemals abgeschlossen, da es potenziell und absichtlich von den Schritten

it, and it retraces and absorbs the habits and itineraries of the people who live with it.

It underlines and generates a dichotomy between the impermanence of life and the endurance of the inanimate world: successions of generations may walk or have walked across it, and will also be agents of historical changes in which they participate. The floor is the boards of the stage of the human comedy and is itself a résumé of the weights of the players' bodies, of the play and its sets as material presence, of the agility of its plot and performance.

The floor is a concentrate of the weight of the domestic female labour which in bent positions and with circular movements have kept it clean. In the corpus of Rachel Whiteread's work, her floors constitute the visual and conceptual synthesis of the complex and polyhedral dynamic of stimuli to which she invites the spectator to react. They present themselves at one and the same time as autonomous subjects and as copies in negative of pre-existent entities with dense reverberations, both politically and socially. They are both sculpture and architecture. When we come into contact with these works – physically walking across them, in whatever direction we choose – they deploy a mechanism of perception that involves the spectator no less in space than in time. This gravitational and sensorial interaction between the work and the spectator is a basic and constituent part of the work. The artist considers these floor sculptures to be permanently in a state of becoming: they are always being modified, constantly abraded and worn away, by the feet that tread their surfaces. Traces of footsteps left in the past are layered one on top of the other and grow confused with footsteps that fall in the present. There are layerings, here, of the human presence in much the same way that historical periods and their architectures lie stratified in our great, contemporary cities,

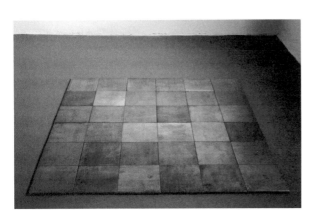

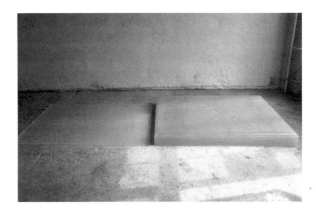

Carl Andre
36 Cyprion 6 x 6 1984
Kupfer / Copper
36 Kupferplatten (6 x 6) auf dem Boden /
36 unit squares (6 x 6) on floor
je / each 1 x 20 x 20 cm;
gesamt / overall 1 x 120 x 120 cm
Collection Hans Böhning, Köln / Cologne

Rachel Whiteread
Untitled (Ceiling Floor Piece) 1993
Gummi / Rubber
2 Teile / units, 12 x 140 x 120 cm
und / and 2,5 x 140 x 120 cm

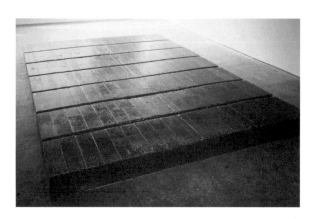

Rachel Whiteread
Untitled (Floor) 1994/95
Kunstharz / Resin
25,4 x 22,9 x 33 cm

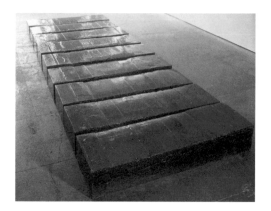

Rachel Whiteread
Untitled (Resin Corridor) 1995
Kunstharz / Resin
389 x 136 x 21,5 cm

auf seiner Oberfläche verändert werden kann. Die Spuren der Schritte aus der Vergangenheit überlagern und vermischen sich mit den Schritten aus der Gegenwart, so entsteht eine Stratifikation der menschlichen Präsenz ähnlich jener der Zeitepochen mit ihren architektonischen Zeugnissen in den heutigen Großstädten, wo sich Vergangenheit und Gegenwart wie in ein Mosaik, das nicht auf Anhieb lesbar und das stets veränderbar ist, einfügen.

Die Dehnbarkeit von Gummi oder Kunstharz oder das auf das Metall der Böden von Rachel Whiteread aufgetragene Wachs wie auch schon der Abguss des zuvor vom originalen Boden genommenen Gipsabdrucks verstärken diese Tendenz, das ursprüngliche Aussehen zu verändern, vergleichbar einer horizontalen Leinwand, die fortwährend und subtil durch Zeit und Zufall bearbeitet wird: fast wie ein Porträt von der Unordnung des Lebens. Bei der Entscheidung, von einem Boden aus Fliesen, die als Raster angeordnet sind, einen Abdruck anzufertigen, geht es weniger um die Objektivierung der Serialität – wie bei den revolutionären Skulpturen von Carl Andre in den späten 1970er Jahren – als vielmehr um die Schaffung eines Kontextes, in dem die synoptisch-ästhetische Funktion, die das ganze Netzwerk bestimmt, ausgeglichen und abgeschwächt wird durch die unvermeidlichen Ungenauigkeiten, die durch den menschlichen Eingriff und den Fluss der Zeit entstehen. Das Ganze erscheint dadurch organisch, vermenschlicht, mit Lebensenergie aufgeladen wie jene frühen Zeichnungen der Küchenfliesen von Brice Marden aus den 1970er Jahren, die durch Frottage mit gepresster Kohle entstanden sind. Ordnung und Unordnung manifestieren und kontrastieren sich in einem Gewebe, das die Geschehnisse in ihrer Unvorhersehbarkeit festhält und sich einschleicht in den Spalt zwischen Kunst und Leben. Im Werk Untitled (Ceiling Floor Piece),

where past and present are superimposed in an always changing and not immediately discernible mosaic. The softness of the industrial gums and resins or of the wax applied to the metals that constitute Whiteread's floors, which in turn are cast from plaster casts of real floors, increases their tendency to shift in appearance, like canvases stretched out flat and continually and subtly repainted by time and chance, nearly as though they were portraits of the chaos of life. The making of casts of gridded, tile floors has less to do with an objectification of seriality – as with the revolutionary sculptures of Carl Andre in the second half of the 1970's – than with the creation of a context in which the synoptic function of the grid as a principle of ideal, aesthetic order is questioned and counterbalanced by the inevitable imperfections created by human intervention and the wear and tear of time. The whole presents itself as organic, humanised, and charged with energy, like those seminal drawings by Brice Marden, again of the 1970's, made by way of charcoal rubbings of the tiles in his kitchen. Order and disorder grow manifest and contrast with one another in a warp and woof that nets events in all their final unforeseeability, thus reducing the gap between art and life, or, better, siting itself in a place within it. In **Untitled (Ceiling Floor Piece)**, 1993, now at the Tate, the artist presents the two polarities that define and delimit the horizontality of a room by lining up their casts in polyurethane gum one next to the other: floor and ceiling turn into an unexpected continuum. The space in which life takes place – the area between them of physical movement – is zeroed out; compressed and at the very same time brought more thoroughly, paradoxically, to light by way of its own disappearance; swallowed up into sculptural corporeality; subjected to an analysis that reveals its singularity. The earth

1993, heute in der Tate Gallery, präsentiert die Künstlerin die beiden Polaritäten, die die Horizontale eines Raumes definieren und begrenzen, und ordnet die beiden Abgüsse aus Polyurethan nebeneinander an. Fußboden und Plafond fügen sich hier zu einem unerwarteten Kontinuum. Der Lebensraum, der Bereich der physischen Bewegung, ist ausgelöscht, komprimiert und durch sein Verschwinden auf paradoxe Weise zugleich hervorgehoben, von der skulpturalen Körperlichkeit verschluckt und auf seine Eigentümlichkeiten hin analysiert. Die Erde und der Himmel der häuslichen Welt, des Alltags durchdringen und spiegeln sich in der Monochromie, in der Transformation der Materie und der Sinnlichkeit des Gummis. Die Proportionen bleiben bestehen und erinnern an die Bauweise des Wohnraumes, ihre Transfiguration in eine ungewöhnliche Komposition überträgt dessen Häuslichkeit samt der metaphorischen und mnemonischen Energie in die Form der Skulptur. In Untitled (Floor), **1994/95,** ebenfalls in der Tate Gallery, oder in Untitled (Resin Corridor), **1995,** hat der Abdruck eines Bodens aus Polyester-Kunstharz eine Stärke von circa 25 Zentimetern erhalten. Die Flachheit des Bodens bekommt hier Tiefe und Ausdehnung. Was entsteht, ist Präsenz und Imposanz durch die Energie und die Dreidimensionalität der Skulptur. Das kleine, aber unübersehbare Hindernis der Stufe steigert die Phase des Bewusstwerdens und der verlangsamten und – im Vergleich zur transparenten oder reflektierenden Struktur der Materie – erweiterten Betrachtung des Werkes. Es lenkt die Aufmerksamkeit auf die Details wie die Risse, die im Lauf der Zeit durch Abnutzung entstanden sind, die teilweise wie Abschürfungen auf der Haut aussehen, wo die Berührungen und die Empfindlichkeit der Oberfläche offenbar werden. Die Verletzlichkeit und Vergänglichkeit des Menschen sind eingeschrieben in den

and sky of the scene of domestic life, of daily experience, mutually penetrate the one into the other, reflecting each other in monochrome, as sensual equivalents the one of the other, thanks to their transmutation into one and the same material. Their proportions remain and remind us of the architecture of the houses in which we live, but the unusual composition they have come to share transfigures them: these familiar constructs enter the realm of sculpture and are charged with memory and metaphor. In **Untitled (Floor)**, 1994/95, again at the Tate, or in **Untitled (Resin Corridor)**, 1995, the cast in polyester resin of a floor has the thickness of about 25 centimetres (ten inches). The flatness of the floor takes on depth and dimension. The works give life to a presence that grows imposing by virtue of the energy and the three-dimensional nature of sculpture. The small but nonetheless significant obstacle of the step at the edges of the works invites the viewer to a slower reading of the work, and to a longer period of awareness, more dilated. Coupled with the nature of the material in which the works are made – diaphanous, and reflecting – such an attitude directs attention to the details of the cracks in their surfaces, to these proofs of the wear and tear of time which spectrally emerge like abrasions on the skin, showing the surface to be something tangible and sensitive. The transience and frailty of the human being are voiced in the erosion created by our transit, and by the traces we leave on matter. In turn, if we think of the socio-political connotations of architecture and the context in which it functions as inseparably linked, the transposition of a structural or architectural element from one context to another casts a critical light on its original setting and reframes its subsequent setting with the perception of an historical evolution.

Verschleiß, der durch den Menschen und seine Bearbeitung der Materie entsteht. Und weiter, wenn die Architektur und der Kontext, in dem sie entsteht, auf der Ebene der soziopolitischen Konnotation untrennbar sind, so macht die Überführung eines strukturellen architektonischen Elements von einem Kontext in einen anderen seine Herkunft auf kritische Weise anschaulich, und sie setzt den neuen Kontext unter den Bedingungen der geschichtlichen Evolution neu zusammen.

In Untitled (Bronze Floor), **1999/2000,** wird der Abguss eines Bodens aus dem Haus der Kunst in München in einem neuen Gebäude ausgestellt. Der ursprüngliche Boden geht auf die Mitte der 1930er Jahre zurück, die Zeit, als in Deutschland der Nationalsozialismus an der Macht war. Die Überführung eines Zeugnisses desselben in ein zeitgenössisches Gebäude führt unausweichlich zurück zur geschichtlichen Erinnerung an diese tragische Vergangenheit, die den politischen Gehalt der Skulptur verdichtet. Die Bronze nimmt, wenn sie mit chemischen Mitteln und Wachs behandelt wird, eine weiße Patina an, die sich, sobald das Publikum darübergeht, in Aussehen und Art verändert, was als eine visuelle Paraphrase für den Umgang des Menschen mit der Geschichte gesehen werden kann. Auch die wechselnden Bestimmungen und Zwecke eines Gebäudes belegen die sozioökonomischen Veränderungen eines Ortes und seiner Bewohner.

Untitled (Cast Iron Floor), **2001, wurde erstmals anlässlich der Einzelausstellung von Rachel Whiteread am Eingang der Serpentine Gallery in London gezeigt. Dabei handelt es sich um den Abguss eines Fußbodens aus jenem Haus im Londoner Stadtteil Bethnal Green, das die Künstlerin und ihr Lebensgefährte als Wohnhaus und Atelier gekauft haben. Dieser Bezirk hat, wie das East End insgesamt, im Lauf der Jahrhunderte zahlreiche Migrations-**

With **Untitled (Bronze Floor)**, 1999/2000, the cast of a floor from the old building of Munich's Haus der Kunst is sited in the institution's new building. The original floor dates to the mid-1930s, when National Socialism rose to power in Germany. The removal of a fragment of that period to a present-day building leads inevitably to the historical memory of that tragic past, and the sculpture is laden with political implications. Treated with wax and various chemical substances, the bronze takes on a white patina that when buffed by the steps of the public which walks on top of it changes appearance and definition, visually paraphrasing the effect of human beings on history. Changes in the use to which a building is put can likewise testify to the socio-economic transformation of a place, and thus of its populace.

Untitled (Cast Iron Floor), 2001, first shown at the entrance of the retrospective of Whiteread's work at London's Serpentine, is the cast of the floor of a building that the artist and her partner purchased as a place in which to live and work in the London quarter of Bethnal Green. Like the whole East End, this area of London, in the course of centuries, has witnessed waves of immigration from all parts of the world, and constitutes – not only for Whiteread, but also for many other artists who live in the area, such as Gilbert & George – a metaphor for the epos of the whole of humanity, for human variety, and the flow of history. The site on which this building stands originally housed a Baptist church, then later, at the beginning of the twentieth century, a synagogue; during the Second World War it was bombed in the blitz; and thirty years later it was turned into a storeroom, like many others in the area, for the use of a textile manufacturer. The fact that the work is also, now, the cast of a floor in the spaces where the artist herself lives and works clearly creates another level at which it must

bewegungen aus allen Teilen der Welt erlebt und es stellt so wie vieles andere in der Arbeit der Künstler, die dort leben, zum Beispiel Gilbert & George, eine Metapher dar für die Vielseitigkeit der Menschheit oder den Lauf der Geschichte. Dort, wo heute das Haus steht, war ursprünglich eine Baptistenkirche, später, zu Beginn des vorigen Jahrhunderts, eine Synagoge, die im Zweiten Weltkrieg bombardiert wurde, und in den letzten dreißig Jahren wurde das Gebäude als Lagerhaus der Textilindustrie, wie es viele in dieser Gegend gibt, genutzt. Der Umstand, dass es jetzt auch der Abdruck des eigenen Lebens- und Arbeitsplatzes ist, fügt dem Haus zwangsläufig noch eine weitere Bedeutungsebene hinzu: die Ausstellung eines privaten und eines kreativen Raumes an einem öffentlichen Ort. Durch die Schritte der Besucher wird das schwarzpatinierte Eisen der Skulptur poliert und allmählich tritt der ursprüngliche Raster der Bodenfliesen hervor. Die Schritte interagieren mit dem Werk durch einen unbewussten Tanz auf dem Territorium der Kunst.

be read: we're dealing here with the public exhibition of a private and creative space. The public's footsteps on the sculpture's fired, black patina polish its surface, and slowly result in the re-emergence of the original grid of the flooring tiles. These footsteps interact with the work in an unconscious dance on the territory of art.

Untitled (Bronze Floor) 1999/2000
Bronze, patiniert /
Patinated bronze
98 Einheiten / units,
je / each 50 x 50 cm;
gesamt / overall 350 x 700 cm
Courtesy of the artist and
Luhring Augustine, New York

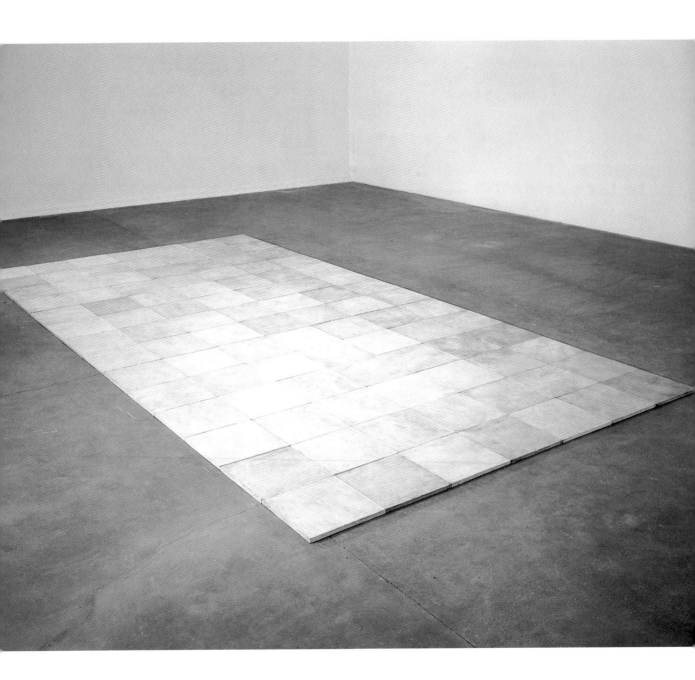

Untitled (Cast Iron Floor) 2001
Gusseisen, schwarz patiniert /
Cast iron and black patina
99 Einheiten / units
1 x 502 x 414 cm
Courtesy of the artist and
Luhring Augustine, New York

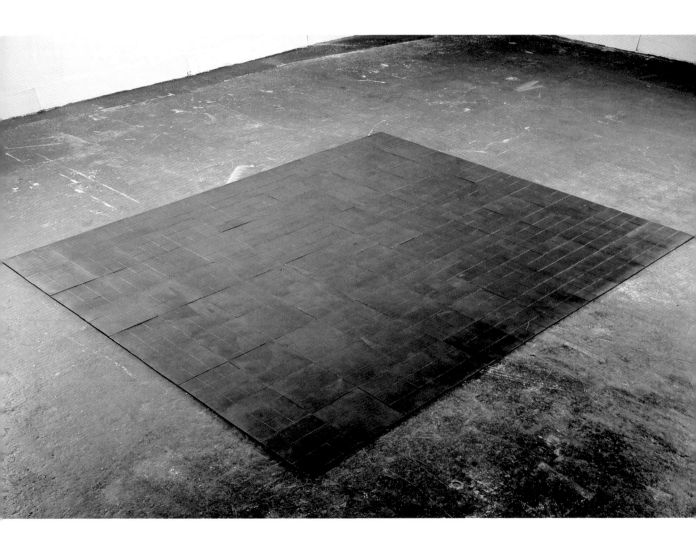

Untitled Floor (Thirty-Six) 2002
Aluminiumguss / Cast aluminium
36 Fliesen / tiles, je / each 68 x 68 cm;
gesamt / overall 407 x 407 x 2,75 cm
Courtesy of the artist and Luhring
Augustine, New York

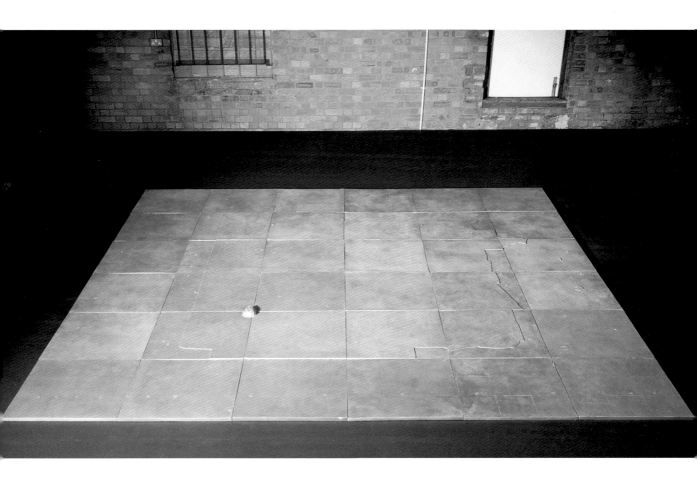

Untitled (Floor, Small) 1992
Gips / Plaster
24,2 x 91,4 x 86,4 cm

Untitled (Floor) 1992
Gips / Plaster
24,1 x 280,7 x 622,3 cm

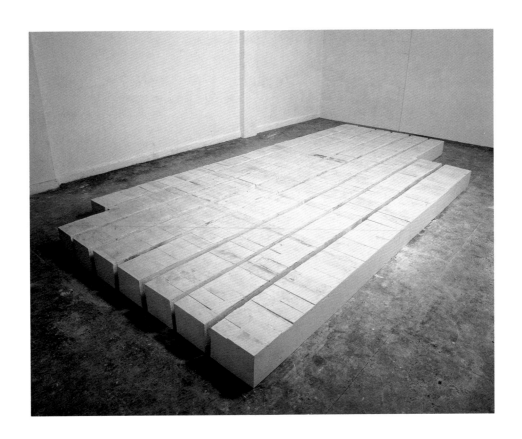

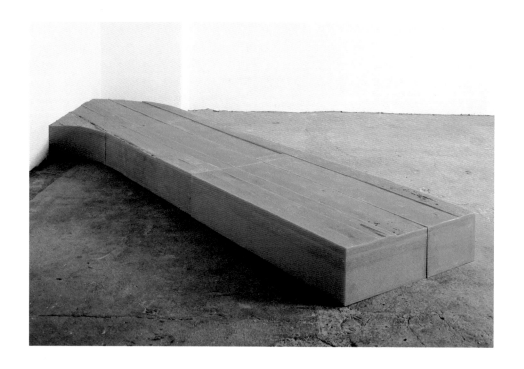

Untitled (Wax Floor) 1992
Wachs und Polystyrol /
Wax and polystyrene
28 x 100 x 465 cm

Untitled (Platform) 1992
Gips und Polystyrol /
Plaster and polystyrene
28 x 157 x 326 cm

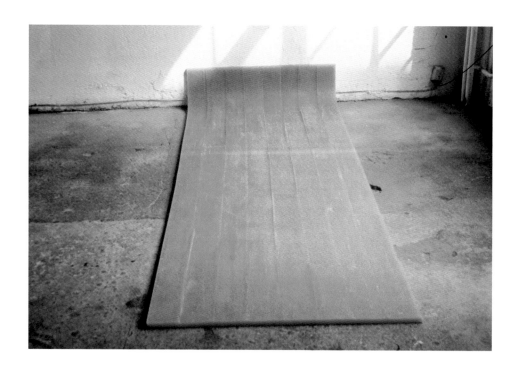

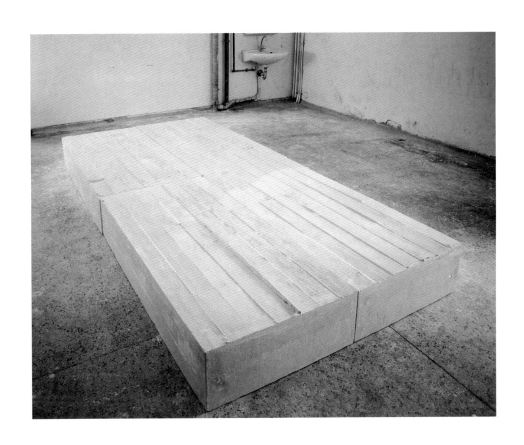

Untitled (Amber Floor) 1993
Gummi / Rubber
2 x 86 x 245 cm

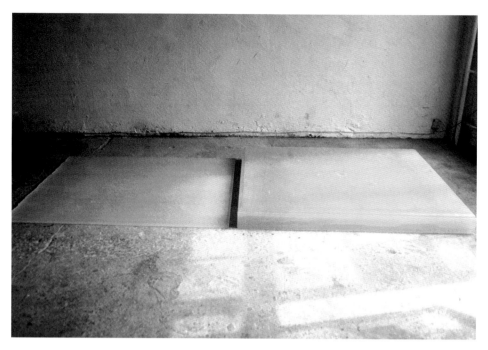

Untitled (Ceiling Floor Piece) 1993
Gummi / Rubber
2 Teile / units, 12 x 140 x 120 cm
und / and 2,5 x 140 x 120 cm

Untitled (Rubber Floor) 1993
Gummiabguss /
Cast rubber
2 x 29 x 124 cm

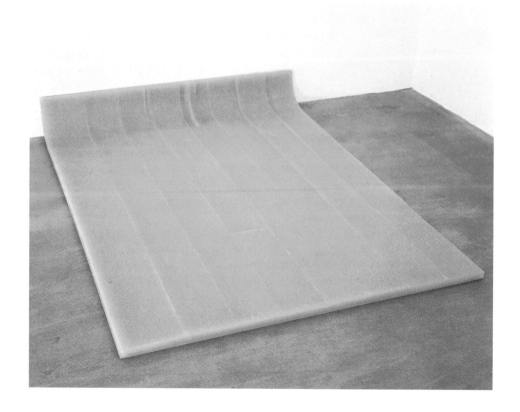

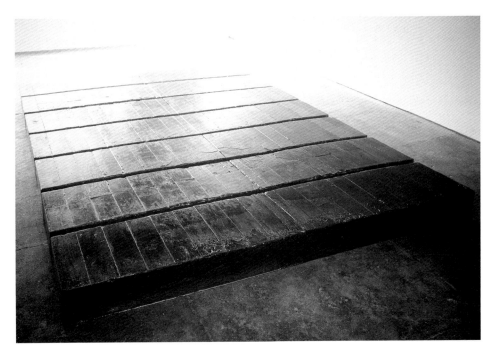

Untitled (Floor) 1994/95
Kunstharz / Resin
25,4 x 22,9 x 33 cm

Untitled (Resin Corridor) 1995
Kunstharz / Resin
389 x 136 x 21,5 cm

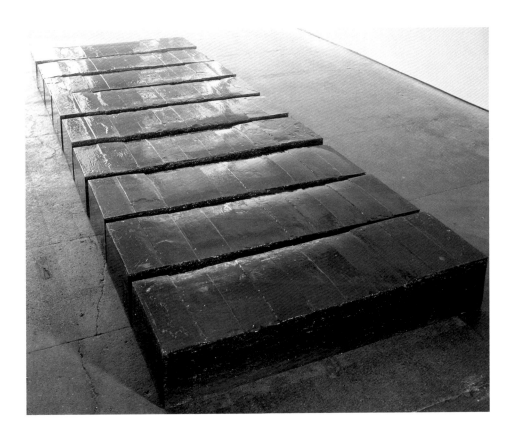

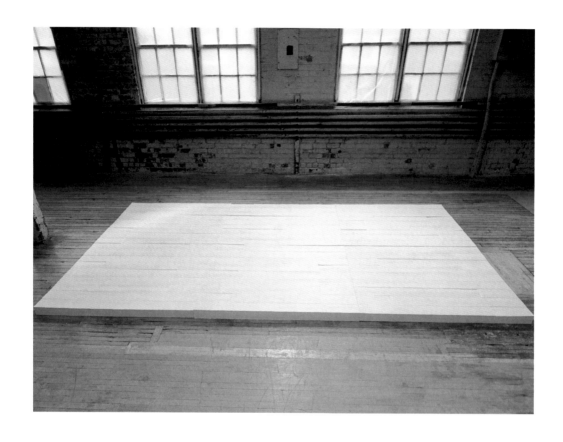

Felt Floor 1997
100-prozentig reine Wolle, Kunstharz /
100% virgin wool impregnated with resin
18 Teile / units,
je / each 137,2 x 45,7 x 7,6 cm

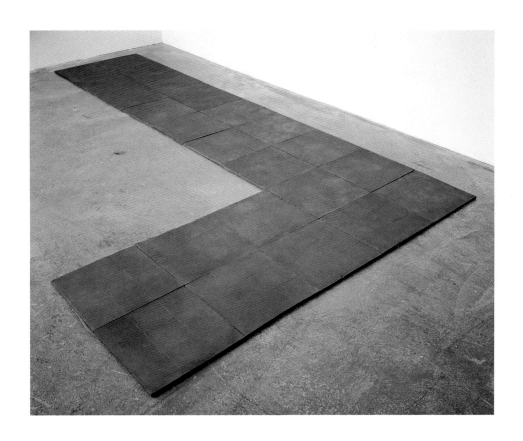

Untitled (Cast Corridor) 2000
Eisenabguss / Cast iron
24 Teile / units, gesamt / overall
1,58 x 226 x 405 cm

Untitled Floor (Twenty-Five) 2002
Aluminiumabguss / Cast aluminium
339 x 339 x 2,75 cm

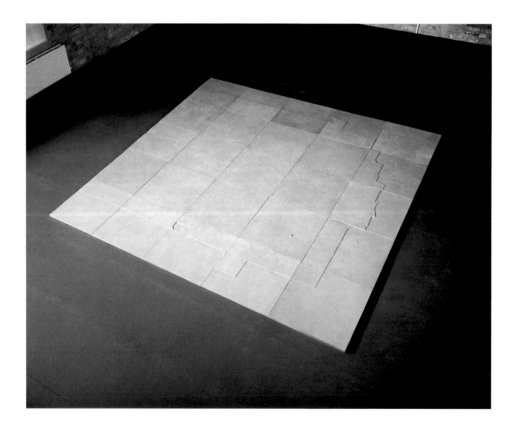

In-Out – I-XIV

The Meaning
of What
Remains

Richard Noble

Leere ist ein paradoxer Begriff. Meist verstehen wir darunter einen Mangel, ein Fehlen von Dingen, Personen oder Geschehnissen, die wir an einem Ort erwarten. Gleichzeitig ist die Leere des Raums ein relativer Zustand: Räume sind leer in Bezug auf das, was wir in ihnen vorzufinden glaubten, aber nicht leer im absoluten Sinne. Anders gesagt: Ein leerer Raum stellt im Gegensatz zu einem Hohlraum etwas dar, nämlich ein ‚Nichtvorhandensein‘, eingegrenzt von physischer Masse (Wänden, Boden, Decke, Fenstern, Türen), deren Beschaffenheit ihn von anderen Räumen unterscheidet. Man könnte behaupten, dass der Begriff des leeren Raums nur dann begreifbar ist, wenn man sich darunter gleichzeitig seine Leere und die ihn umgebende Materie vorstellt. Leere ohne Umfassung ist buchstäblich unfassbar und ebenso unvorstellbar wie unser Universum vor dem Urknall. Deshalb definiert sich Leere immer über ihr Gegenteil; das von ihr bedeutete Nichtvorhandensein von Dingen lässt sich nur aufgrund der physischen Präsenz der sie definierenden Grenzen erfassen.

Rachel Whiteread gießt leere, hohle Räume aus: den Raum unter Treppen, Innenräume und Treppenhäuser, einschließlich der feinen Einkerbungen und oft übersehenen Narben, welche die Innenwände der von uns bewohnten Räume aufweisen. Die Herstellung solcher Abgüsse ist eine komplexe Angelegenheit, obwohl die Idee selbst die elegante Einfachheit einer mathematischen Lösung besitzt. Whitereads Arbeiten stellen eine Reihe schwieriger Fragen – zum körperlichen Bezug des Menschen zu einer Skulptur, die im Raum aufgestellt wird, ihn

Emptiness is a paradoxical concept. We tend to associate it with lack, with the absence of things, persons, or events we expect to find in a given space. But at the same time the emptiness of space is a relative condition; spaces are empty relative to what we expect to find in them, but not in an absolute sense. Another way of putting this is to say that an empty space, as opposed to a void, is something. It is an absence bounded by physical mass (walls, floors, ceilings, windows, doors) that distinguishes it from other spaces. Indeed it is arguable that the only comprehensible way to think of empty space is to think simultaneously of emptiness and the physical mass that contains it. Emptiness without containment is literally incomprehensible, like trying to imagine the universe before the big bang. So emptiness depends on its opposite, the absence it signifies can only be comprehended through the physical presence of boundaries that define it.

Rachel Whiteread casts empty space: the space underneath chairs, the interior spaces of rooms and stairwells, the subtle indentations and overlooked scars that register on the interior boundaries of the spaces we inhabit. This is a complex thing to do, even though the idea itself has the elegant simplicity of a mathematical proof. Whiteread's sculptures pose a number of difficult questions: about the body's relation to a sculpture that both inhabits and represents space, about the expressivity of physical materials, about why the translation of empty space into physical form seems to release an excess of meaning.

aber auch darstellt; zur Expressivität von Materialien. Sie fragt, warum die Übertragung von leerem Raum in massive Form offenbar ein Übermaß an Inhalten freisetzt.

Indem sie Leere mit Masse füllt, gießt Whiteread eine entsprechend paradoxe Vorstellung in greifbare Form, und zwar die Idee, dass leere Räume Geschichten enthalten können. Leere suggeriert das Fehlen von Inhalten (oben wurde die fehlende Bedeutung angesprochen), andererseits aber ist es gerade ihre Leere, die Räume zu Katalysatoren der Erinnerung macht. So lange Menschen oder Dinge in ihnen wirken, scheinen sie von der Gegenwart bewohnt, obwohl man sich wohl auch bewusst machen könnte, dass sie eine Geschichte verkörpern. Einmal geleert, gewinnen sie Bedeutsamkeit als Gedächtnisstützen: Eine leere Kirche wird eher als ein Baudenkmal und weniger als ein Sakralraum betrachtet; eine leere Fabrikhalle wirkt vielleicht wie ein stadtgeschichtliches Archiv oder ein Zeugnis wirtschaftlicher Veränderungen. Leere aktiviert das Gedächtnis oder zumindest den Versuch, sich vorzustellen, welche Erinnerungen ein Raum beinhaltet. Das liegt daran, dass ein leerer Raum etwas psychologisch ,Unhaltbares' darstellt. Es ist schwer, ihn leer zu lassen, selbst wenn wir nichts als unsere Einbildungskraft haben, um ihn zu füllen. Man stellt ihn sich als künftiges Wohnzimmer, Büro oder Atelier vor; oder man malt sich aus, wie die Menschen früher darin gelebt haben, Generationen, die hier beteten, arbeiteten oder wohnten. Bei diesen Fantasien kann man sich auf kleine Hinweise stützen, auf eine Art fossiler Abdrücke an Wänden, Boden und Decke, die oft übersehen werden. Kleine Dellen, Kratzer, Abnutzungen und Stellen, an denen der Putz bröckelt, sind undeutlich-deutliche Spuren menschlichen Lebens. Sie erzählen uns zwar wenig Bestimmtes, sind aber dennoch Indizien eines Lebens, das für jemanden einst von Bedeutung war.

By casting empty space, Whiteread gives form to an equally paradoxical idea, which is that empty spaces can contain histories. Emptiness suggests an absence of meaning, as I claimed above a lack of significance, yet at the same time it is the emptiness of spaces that activates them as catalysts of memory. As long as people or things are active in them they seem to inhabit the present, though of course one might be aware that they also embody a history. But emptied out, they begin to signify as registers of memory: an empty parish church seems more like an historical site than a house of worship; an empty factory space evokes can seem an archive of local history or evidence of economic change. Emptiness activates memory, or anyway the attempt to imagine what the memories of a space might be. This is because there is something psychologically unsustainable about an empty space. It is difficult to leave empty, even if the only means we have of addressing its emptiness is the imagination. One imagines it as a future living space, or an office, or a studio; or one imagines the life it once contained, the generations that worshipped or worked or lived there over time. In imagining what has gone before in a space one has access to small bits of information, a sort of fossil record on the walls and floors and ceilings of the space. These are often overlooked. Small indentations, scrapes, worn depressions, areas of eroded plaster, offer an indeterminate record of human experience. They tell us little specific, but they are nonetheless evidence of life that was significant for someone.

Rachel Whiteread's casts of walls and stairwells and floors draw attention to the histories of the spaces they contain, and to the capacity of mute physical material to signify as evidence of life. In Bregenz some of the floors, doors and stairwells have been cast from the interior spaces of a building she purchased for a home in

Rachel Whitereads Abgüsse von Wänden, Treppen und Fußböden machen aufmerksam auf die Geschichte des jeweiligen Raums, den sie umfassen und ausfüllen, und auf die Tatsache, dass stumme Materie fähig ist, Zeugnis von gelebtem Leben abzulegen. Manche der in Bregenz gezeigten Böden, Türen und die Treppe sind Teilabgüsse eines Gebäudes, das die Künstlerin als Wohnhaus für sich selbst im Londoner Bezirk Bethnal Green kaufte. Ursprünglich eine Baptistenkirche, wurde es später als Synagoge und schließlich als Stofflager genutzt; die Baugeschichte zeichnet also auch die Geschichte der verschiedenen Einwanderergruppen auf, die sich im Osten Londons niederließen und von hier wieder fortzogen. Besonders der Fußboden und die Treppe verkörpern eine interessante Übersetzung (oder Umdeutung) der in ihren Oberflächen eingelassenen geschichtlichen Informationen. Untitled Floor (Thirty-Six) von 2002 ist das in Aluminium gegossene Negativ eines Fußbodens in ihrem Haus vor dessen Restaurierung. Untitled (Bronze Floor) von 1999/2000 ist ein in gleicher Weise hergestellter Abguss eines Steinfußbodens aus dem Haus der Kunst, München. Nach Abnahme des erstgenannten Abgusses übertrug die Künstlerin ihn in sechsunddreißig Aluminiumquadrate, um wiederum einen exakten Negativabdruck des Bodens zu erhalten. Diesen überzog sie mit einer weißen Farb- und Wachspatina, die nach und nach von den darüberlaufenden Besuchern abgenutzt wird. Dadurch treten langsam die nun erhabenen Einkerbungen und Kratzer im ursprünglichen Boden zu Tage, und die versteinerten Informationen werden im Relief viel deutlicher markiert. Die Aluminiumplatten übertragen also die im ursprünglichen Fußboden gesammelten Informationen in eine neue Positivform, und die Geschichte des Fußbodens tritt durch die patinierte Oberfläche seines Negativabgusses zu Tage.

the London quarter of Bethnal Green. The building had once been a Baptist Church, then later a synagogue and finally a textile warehouse, its history tracking the waves of immigrant communities settling in and then moving out of London's East End. Her casts of the floor and the stairwell in particular effect an interesting translation (or re-signification) of the historical information embedded in their surfaces. **Untitled Floor (Thirty-Six)**, 2002, is a cast aluminium sculpture of a negative impression of the floor of her house prior to its re-development. The same process was used when making **Untitled (Bronze Floor)**, 1999/2000, cast from the stone floor of the Haus der Kunst in Munich. In the case of the former, once a plaster cast was taken of the floor, this was then translated into thirty-six cast aluminium squares to reproduce an exact negative of the actual floor in a silver grey reflective metal. This negative was then covered in a white chemical and wax patina, which wears off very gradually as people walk on the piece. The disappearing patina slowly reveals the now elevated indentations and marks from the original floor, drawing this fossil-like information in much sharper relief. The floor pieces translate into positive form the fossilised information accrued in the old floor; its history literally rises up through the patinated surface of its new negative form.

The effect of this reversal is to establish what we might term an archeology of absence. The history of an empty space is given life in a new form. Both the floor and the information it contains signify differently once Whiteread has cast them. The historical information is made more explicit, and refers us to the past of a specific space, but also to the personal and political possibilities inherent in the recovery of lost histories and lost experience. There is something profoundly elegiac in the way

Die Wirkung dieser Umkehrung erzeugt, was man als ‚Archäologie der Abwesenheit‘ beschreiben könnte. Die Geschichte eines leeren Raums erwacht in neuer Ausformung zu neuem Leben. Sowohl der Fußboden als auch die in ihm enthaltenen Informationen signalisieren etwas anderes, sobald Whiteread sie abgeformt und gegossen hat. Die historische Information wird deutlicher und verweist uns auf die Vergangenheit eines bestimmten Raums, aber auch auf die persönlichen und politischen Möglichkeiten, welche die Wiedergewinnung verlorener, vergessener Geschichte und Erfahrung bereithält. In der Art, wie Whitereads Arbeitsweise noch die unscheinbarsten Dellen und Kratzer in versteinerte Artefakte verwandelt, liegt etwas zutiefst Elegisches. Wie in einem alchemistischen Prozess gewinnt das bislang unbemerkte Mal eines längst vergessenen Missgeschicks an Eindrücklichkeit; durch den Abguss wird es bedeutsam. Das ist schwer zu erklären, aber vielleicht vergleichbar mit einem Fossilienfund, der wichtiger und aufschlussreicher erscheinen kann als der Fund des Originals. Durch Whitereads Abgüsse eines Raums werden dessen Oberflächen historisiert und zu einem wichtigen Teil der Gegenwart, indem die Künstlerin sie mit der Vergangenheit verbindet. Sie erinnert uns daran, dass dies ein Ort ist, an den wir niemals ganz zurückkehren können.

Gleichzeitig setzt Whitereads Übertragung der zerkratzten Fußbodenfläche in die Positivform eine Überfülle an Bedeutungsinhalten frei. Auch der Boden wird als Skulptur aufgefasst und deshalb mit anderen Inhalten in Verbindung gebracht. In kunsthistorischer Sicht verweisen die Bodenstücke auf die Kunstgeschichte, den Minimalismus und besonders die abstrakte Malerei. Als formale Objekte besitzen sie ihre eigene Logik, und zwar in der Art ihres Bezugs zur Architektur der Gebäude, in denen sie ausgestellt werden, und in der Art ihrer all-

Whiteread's process transforms the most innocuous physical dent or scrape into a sort of fossilized artifact. Through some alchemical process the unnoticed mark of a long forgotten accident is made to signify much more vividly, somehow in being cast it is made more significant. This is difficult to explain, but perhaps it is similar to the way that finding a fossil of something can seem more significant than finding the thing itself. By casting the surface of a space Whiteread historicices it; she makes it a significant part of the present by consigning it to the historical past. She reminds us that it is a place to which we can never fully return.

Yet at the same time Whiteread's process of translating the scarred surface of the floor into a positive form releases an excess of meaning. The floor also signifies as a sculpture, and therefore in relation to an entirely different register of meanings. As sculptures the floors refer to the history of art, to minimalism and abstract painting particularly; but they also have an internal logic of their own, as formal objects, in the way they relate to the architecture in which they are installed and in the way they are transformed over time by their interaction with their audience. In appearance at least, these floor pieces bear an obvious resemblance to Carl Andre's floor pieces: grid-like rectangular or square forms lying flat against the gallery floor. We are invited to gaze at Whiteread's floors, walk around them and indeed on top of them. They have a quiet and static simplicity about them that is completely absorbing; they compel solely as objects and in this way make reference to minimalism. Yet at the same time this is really only the beginning of one's experience of them. Over time, as the patina wears off, their surfaces reveal the historical information embedded in their surfaces and expose the lines between the bronze or

mählichen Verwandlung durch das Zutun der Ausstellungsbesucher. Zumindest was ihr äußeres Erscheinungsbild angeht, haben Whitereads Bodenarbeiten deutliche Ähnlichkeit mit Carl Andres Bodenskulpturen: Es sind flach auf dem Fußboden des Ausstellungsraums liegende, rasterartig angeordnete rechteckige oder quadratische Platten. Wir werden eingeladen, Whitereads Böden anzuschauen, um sie herum zu gehen und sie sogar zu betreten. Sie sind von einer ruhigen, statischen Einfachheit, die fasziniert. Und doch ist das nur der Anfang des Erlebnisses, das sie einem bieten. In dem Maße, in dem ihre Patina abgetreten wird, offenbaren ihre Oberflächen die in sie eingelassenen geschichtlichen Informationen und legen die Fugenlinien zwischen den Platten aus Bronze oder Aluminiumguss frei, um ein graues Bildraster zu suggerieren, das an Gemälde von Agnes Martin erinnert. Die Betrachter werden also – ob auf einmal oder Schritt für Schritt – in den Herstellungsprozess des Werkes einbezogen, in einen Prozess, der auf poetische Weise spiegelt, wie der Einzelne zur gemeinsamen Geschichte unserer gebauten Umwelt beiträgt.

Wenn Wände, Böden und Decken die – als solche allerdings nicht erkannte – Eingrenzung der menschlichen Erfahrung der Leere darstellen, so verkörpern Türen und Türöffnungen einen anderen Zweck. Bei ihnen geht es weniger um Räume, die wir bewohnen, sondern vielmehr um unsere Hin- und Herbewegungen zwischen beiden. Wie Treppenhäuser sind auch Türen Übergänge, von denen man von einem Raum zum nächsten, von innen nach außen, vom privaten in den öffentlichen Raum, von der Jugend ins Erwachsenenalter wechselt. Sie bezeichnen räumliches wie zeitliches Fortschreiten. Das Überschreiten von Schwellen markiert die Stationen unseres Lebens. Die Jugend geht durch Türen, um das Versprechen der Zukunft einzulösen, für die Älteren dagegen schließen sich

cast aluminium squares to suggest a soft grey painterly grid that recalls the paintings of Agnes Martin. The audience thus finds itself, however contingently or incrementally, implicated in the ongoing production of the work, a process that poetically mirrors the way individual lives unconsciously contribute to the shared history of our built environments.

If walls and floors and ceilings are the unrecognized boundaries defining our experiences of emptiness, doors or doorways embody a different function. They are less about the spaces in which we live than about our movement between them. Like staircases, they are areas or points of transition: from one room to another, from inside to outside, from private to public, from youth to adulthood. They signify spatial and temporal movement. We mark out our lives by passing through thresholds; youth pushes through doors in order to fulfill its promise, while age closes doors on one chapter after another. Yet at the same time doorways also signify as barriers; against entry, or escape, or the real or imagined threat of what lies on the other side. They can protect us from the world outside, but they can also keep us from the spaces we aspire to be. As sculptures Rachel Whiteread's doors signify very differently from her casts of rooms and floors. Spaces of transition tend not to accrue the residues of lived experience. They refer us not to shared or common experience of space, but rather to the equally significant process of moving from one space to another. They are less elegiac, less poignant than works like **Ghost** or **Untitled (Bronze Floor)**. Nonetheless they resonate psychologically. Leaning against a wall, either singly or in groups, they confront us with both the invitation to go boldly through and the impossibility of entry; the necessity of striving onward in the face of resistance and the subtle intimation of its ultimate futility.

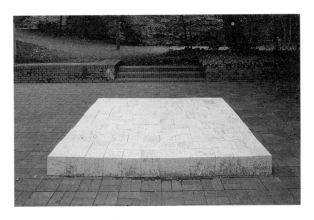

Carl Andre
144th Travertine Integer Krefeld 1985
144 Travertin-Blöcke auf dem Boden /
144-unit square on floor (1 x 12 x 12)
je / each 20 x 20 x 20 cm;
gesamt / overall 20 x 240 x 240 cm
Privatsammlung / Private Collection

Agnes Martin
Untitled No. 1 1977
Museum Moderner Kunst Stiftung Ludwig Wien
© Mumok, Museum Moderner Kunst
Stiftung Ludwig Wien

nach und nach bestimmte Türen. Türen sind aber auch Barrieren für Eindringlinge und für Flüchtende, Barrieren gegen reale oder eingebildete Bedrohungen von außen. Sie schützen uns vor der Außenwelt, können uns aber auch den Weg in Räume versperren, in die wir uns wünschen. In Form von Skulpturen verkörpern Rachel Whitereads Türen vollkommen andere Inhalte als ihre Abgüsse von Innenräumen oder Fußböden. Durchgangsbereiche sind tendenziell keine Reservoirs der Erinnerung an gelebtes Leben. Sie rufen uns nicht gemeinsame Raumerlebnisse ins Gedächtnis, sondern vielmehr die ebenso bedeutsame Erfahrung der eigenen Fortbewegung von Raum zu Raum. Whitereads Türen wirken zwar weniger elegisch, weniger eindringlich als andere ihrer Werke, zum Beispiel Ghost oder Untitled (Bronze Floor), haben aber dennoch psychologische Wirkung. An die Wand gelehnt, einzeln oder in Gruppen, konfrontieren sie uns mit der Einladung und Möglichkeit, mutig hindurchzugehen – in den Raum dahinter einzutreten –, und mit der Notwendigkeit, allem Widerstand (und dem leise gehgten Verdacht, dass es letztlich zwecklos sein könnte) zum Trotz vorwärts zu streben.

Für In-Out – I - XIV, (2004), schuf Rachel Whiteread Abgüsse von vierzehn Türen von verschiedenen Standorten in London, indem sie jeweils einen (Negativ-)Abdruck von beiden Türseiten abnahm und sie dann ‚Rücken an Rücken' wieder zusammenfügte. Daraus entstanden Türskulpturen, die etwa doppelt so dick sind wie die Originale. Die Umkehrung der Türoberflächen hat die allen Plastiken Whitereads eigene ‚alchemistische' Wirkung, ein ganz gewöhnliches Objekt in etwas geradezu beunruhigend Schönes zu verwandeln. Diese Türen sind eigentlich nichts Besonderes; Whiteread scheint sie wahllos von Fabriktüren, Hauseingängen, Schlafzimmer- und anderen Türen in Wohnungen abgenommen zu haben. Offensicht-

For **In-Out – I - XIV**, 2004, Rachel Whiteread has cast fourteen doors from different locations around London. The doors are made by casting a negative impression of both sides of a particular door, and then placing the two impressions together back to back. The result is a door-shaped sculpture, which is roughly double the thickness of the original door from which the two casts were taken. The process of reversing the doors' surfaces has the alchemical effect (common to all Whiteread's sculpture) of transforming an ordinary, entirely mundane object into something disconcertingly beautiful. There is nothing particularly special about these doors; they seem to be taken randomly from entrances to houses or domestic spaces like bedrooms, and also from industrial buildings. Each has a surface that was evidently marked by geometric indentation; windows and beveled rectangular designs broke up the surface of the doors in order to make them seem (one supposes) less forbidding, less monolithic, and so to invite the possibility of passage even when closed. Looking at such doors, as one does hundreds of times a week, it is difficult to think of them as other than purely functional objects; something one opens or closes or passes through without the slightest regard. Yet Whiteread's process allows us to see their underlying aesthetic principle. By casting them in white or grey plaster, she severs them from their functional purpose and transposes their surfaces into geometric patterns of raised rectangular shapes. They achieve a kind of independent objecthood as sculptures. They become objects of considerable formal beauty, which satisfy solely as aesthetic objects.

Yet at the same time this alchemical transformation of ordinary functional objects into sculptures resonates beyond the aesthetic. These sculptures also signify as doors, though not simply as functional objects to pass

lich weisen alle Originale Kassetten und geometrische Einkerbungen auf; Fenster und erhabene rechteckige Leistenmuster beleben ihre Oberflächen, was vermuten lässt, dass sie weniger abweisend, weniger monolithisch erscheinen und selbst in geschlossenem Zustand zum Eintreten einladen sollen. Wenn man sich (wie man das jede Woche Hunderte von Malen tut) solche Türen anschaut, fällt es schwer, sie nicht ausschließlich als rein zweckmäßige Elemente anzusehen – als Türen eben, die man öffnet, schließt und durch die man hinein- und hinausgeht, ohne sie wirklich zu beachten. Whitereads schöpferischer Prozess eröffnet uns nun den Blick auf ihre künstlerischen Werte. Mit weißem oder grauem Gips gießt sie die Türen ab, entfremdet sie ihrer ursprünglichen Funktion und transponiert ihre Oberflächen in rechteckige geometrische Muster aus erhabenen Formen. Als Skulpturen erlangen sie eine Art freie Objekthaftigkeit von beachtlicher Formschönheit und befriedigen allein aufgrund ihrer Ästhetik.

Gleichzeitig beschränkt sich die Wirkung dieser ‚alchemistischen' Verwandlung gewöhnlicher Gebrauchsgegenstände in Kunstwerke nicht nur auf ästhetische Aspekte. Die Skulpturen verkörpern immer noch Türen – wenn auch keine, durch die man tatsächlich gehen kann –, aber Türen als Metaphern für Übergang oder Durchgang. Die gesteigerte Dramatik ihrer Oberflächenreliefs steigert zugleich ihre Bedeutsamkeit als Metaphern und rückt sie in die Nähe von geschnitzten Kirchentüren oder Tempeltoren, ein Erscheinungsbild, das die banal-funktionalen Originale nicht aufweisen. Die Oberflächen der Tür-Skulpturen predigen keine Moral oder Religion, vermitteln aber auf seltsam allumfassende, allgemein gültige Weise, wie wichtig und unausweichlich Übergangsstadien und -zeiten im menschlichen Leben sind. Man könnte auch meinen, dass sie

through, but rather as metaphors for transition. The dramatically increased significance of their raised surfaces makes them more significant as metaphors, closer to the carved doorways to churches or temples than the blankly functional objects from which they were taken. Their surfaces embody no moral or religious narrative, but they are oddly universal in their signification of the importance and inevitability of transition to human life. They might also been seen as hopeful, at least in a provisional way, in the sense that they can find an understated but undeniable beauty in such mundane objects.

The complexity of Rachel Whiteread's practice cannot be grasped in terms of any single idea, but I want to argue that the mystery of why her sculptures work so powerfully on the imagination and sensibilities of their viewers is related to what I have termed an archeology of absence. Giving form to emptiness, and in the process giving voice to the mute physical materials that enclose it, places demands on the viewer's imagination. It requires one to recover the lived experience made explicit on their surfaces by means of one's own imagination. Something similar is true of the way her sculptures based on ordinary objects like doors reveal a hidden aesthetic principle in the object, and in doing so elevate it to higher level of complexity in terms of what it signifies. Her sculptures offer evidence of life, but leave open the question of what form it took or how it should be understood. They are at once formally beautiful and elegiac; quiet, often abstract sculptural forms in which we can find the uncanny experience of anthropomorphic recognition. In giving form to emptiness, they release an excess of meaning into the world.

hoffnungsvoll wirken (wenigstens einen flüchtigen Moment lang), weil sie eine zurückhaltende, aber nicht zu leugnende Schönheit in gewöhnlichen Alltagsdingen entdeckt haben.

Die Komplexität von Rachel Whitereads Schaffen lässt sich nicht mit einem einzigen Gedanken fassen, ich möchte aber behaupten, dass die Frage, warum ihre Skulpturen so anregend und eindrücklich auf die Fantasie und Empfindungsfähigkeit ihrer Betrachter wirken, mit dem zu tun hat, was ich die Archäologie der Abwesenheit nenne. Dass sie der Leere Form gibt – und dadurch den sie umschließenden stummen Materialien eine Stimme –, stellt Ansprüche an die Einbildungskraft des Betrachters. Whiteread fordert ihn auf, die an den Oberflächen ihrer Stücke ablesbaren Spuren gelebten Lebens durch Anwendung der eigenen Fantasie wieder neu zu beleben. Ihre Plastiken sind Belege für einstiges Leben, lassen aber die Frage offen, von welcher Art es war und wie man die Spuren auslegen sollte. Whitereads Skulpturen, die von elegischer Formschönheit sind, ruhig und vielfach abstrakt, vermitteln uns das Wiedererkennen des Menschlichen als verstörende Erfahrung. Indem sie der Leere Form geben, senden sie eine Fülle bedeutungsvoller Botschaften hinaus in die Welt.

In-Out – I-XIV 2004
Plastifizierter Gips mit
inwendigem Aluminiumgerüst /
Plasticised plaster with interior
aluminium framework

I	201 x 80 x 9 cm
II	201 x 80 x 9 cm
III	197 x 76 x 10 cm
IV	197 x 76 x 10 cm
V	191 x 75 x 14 cm
VI	202 x 79 x 10 cm
VII	215 x 91 x 11 cm
VIII	197 x 86 x 10 cm
IX	219 x 91 x 10 cm
X	213 x 91 x 10,5 cm
XI	197 x 75 x 13,5 cm
XII	197 x 76 x 10 cm
XIII	215 x 91 x 11 cm
XIV	197 x 76 x 10 cm

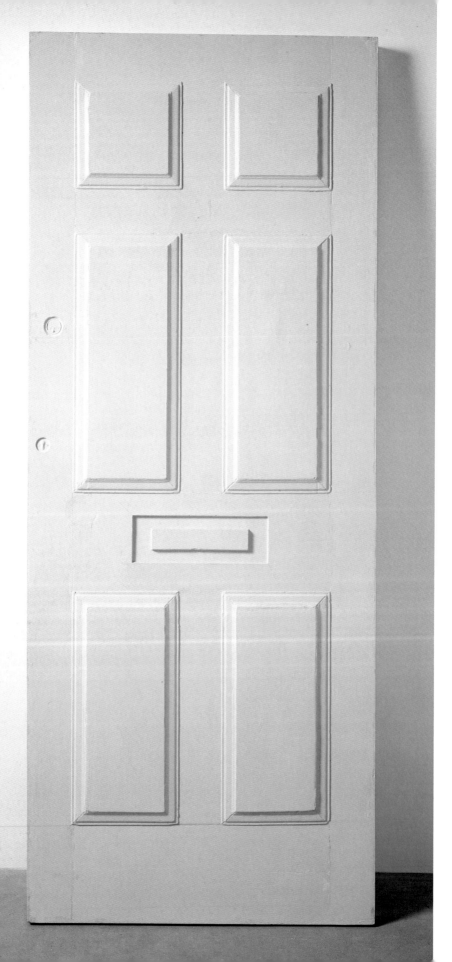

In-Out – I

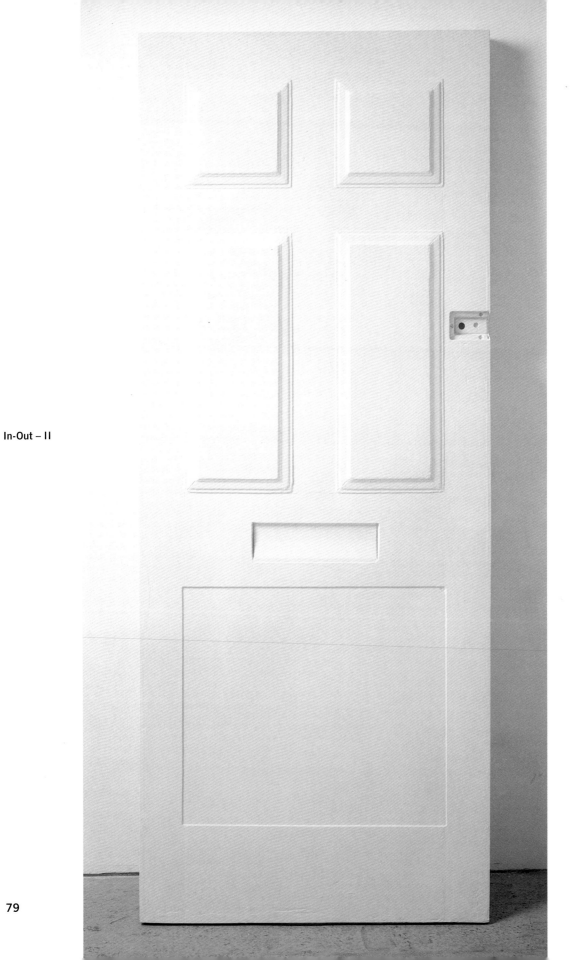

In-Out – II

In-Out – III

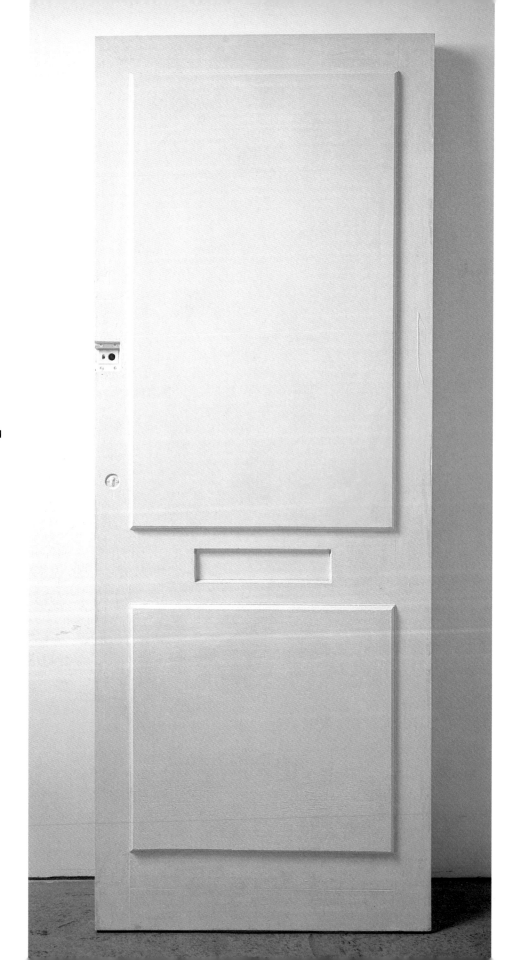

In-Out – IV

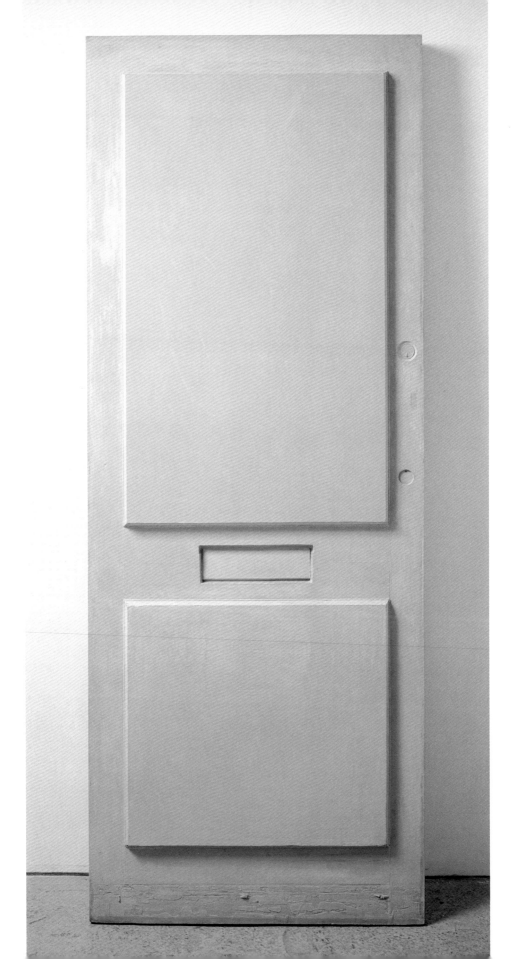

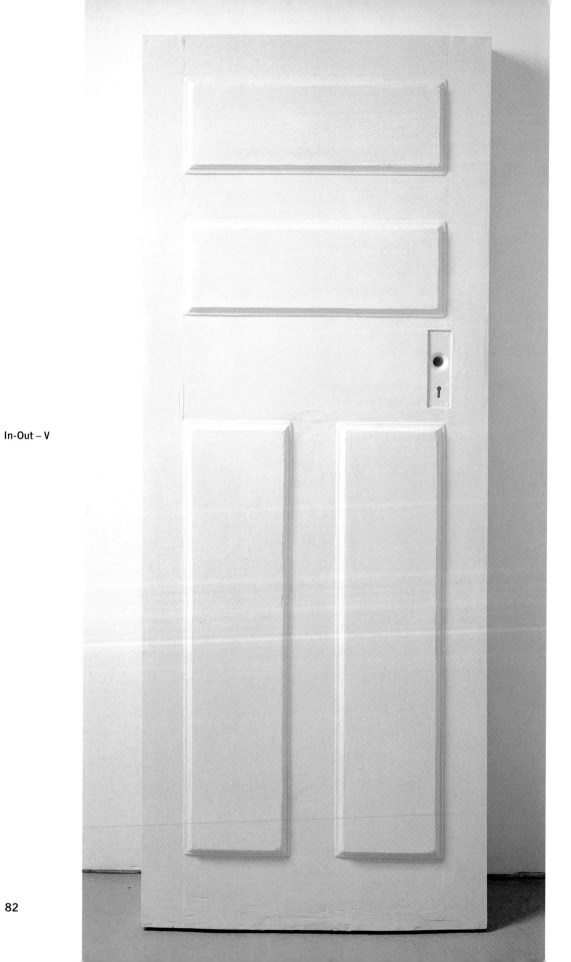

In-Out – V

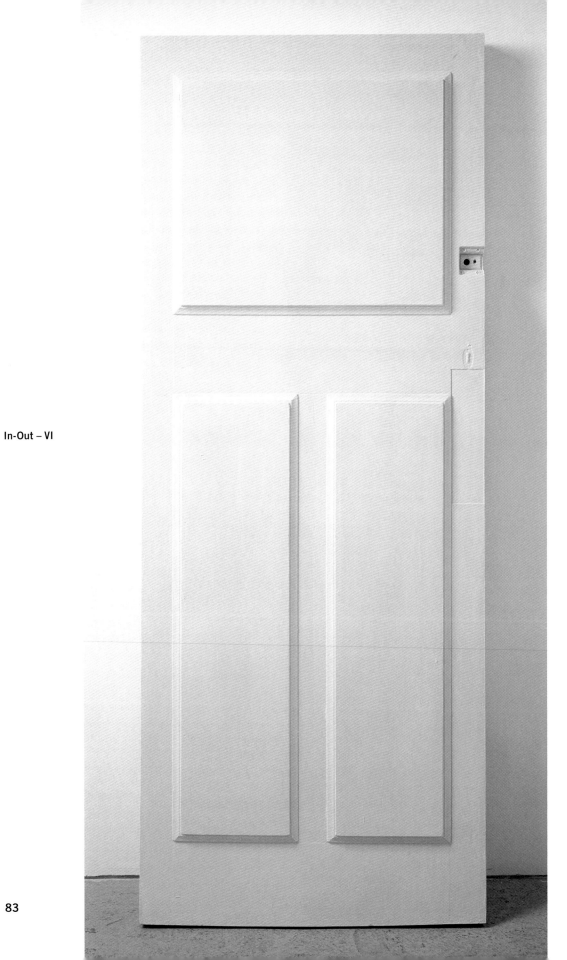

In-Out – VI

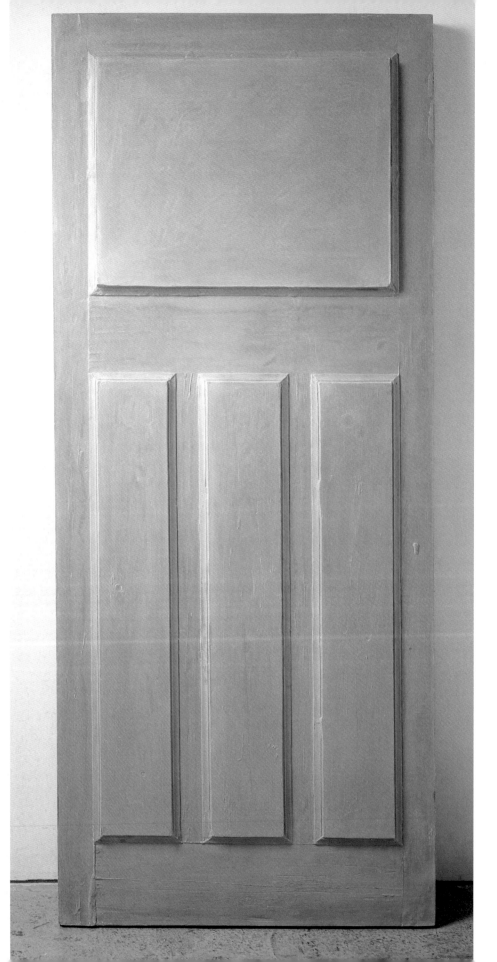

In-Out – VII

In-Out – VIII

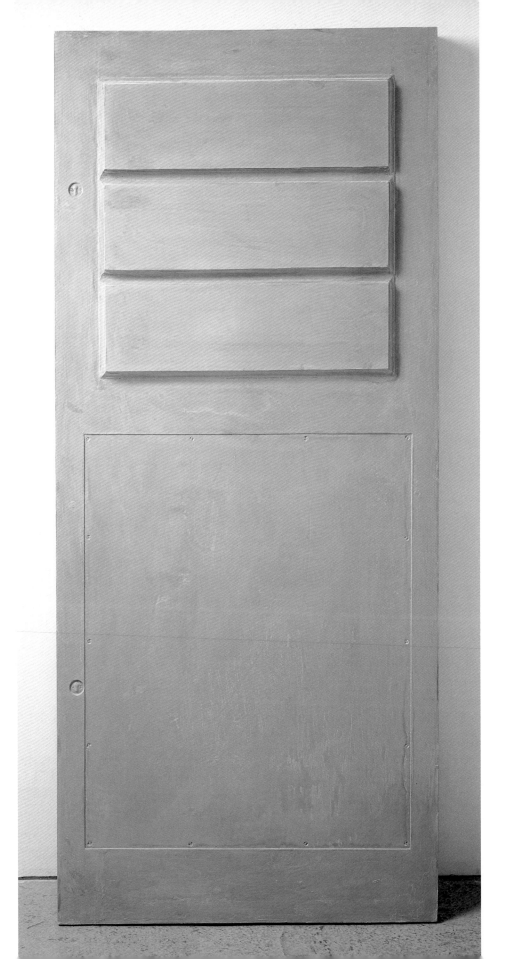

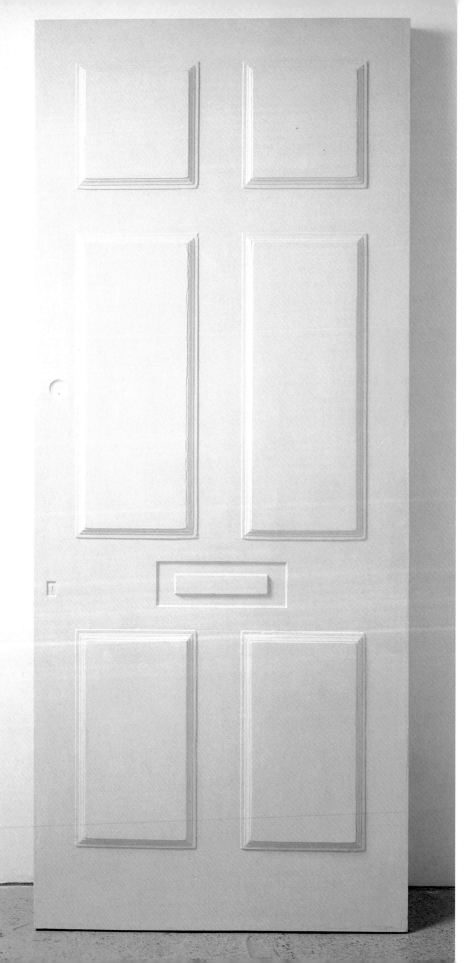

In-Out – IX

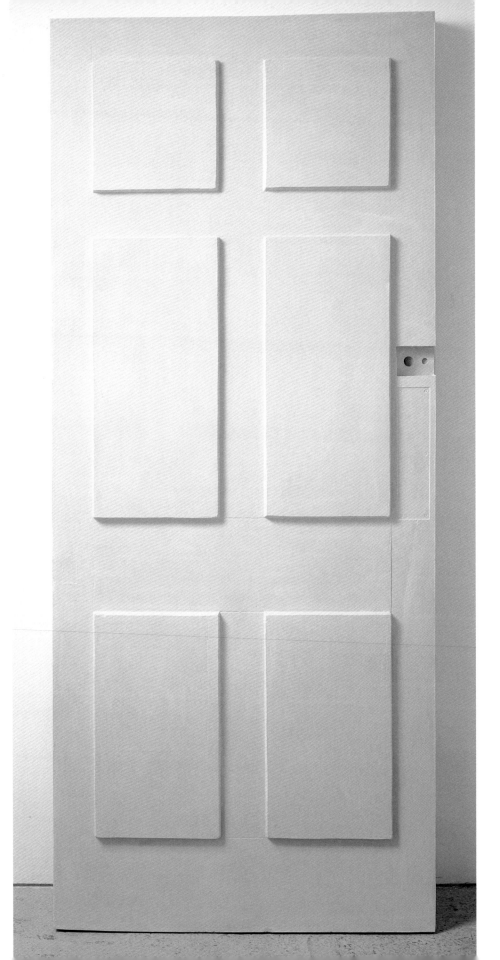

In-Out – X

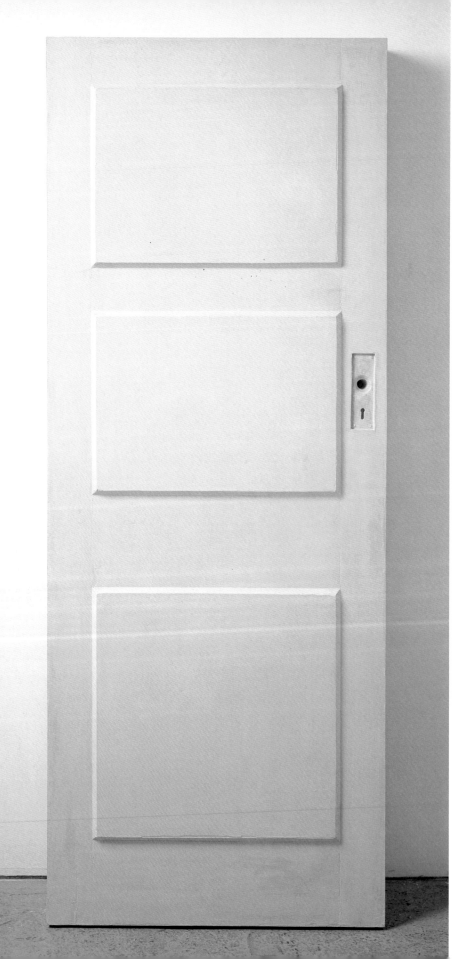

In-Out – XI

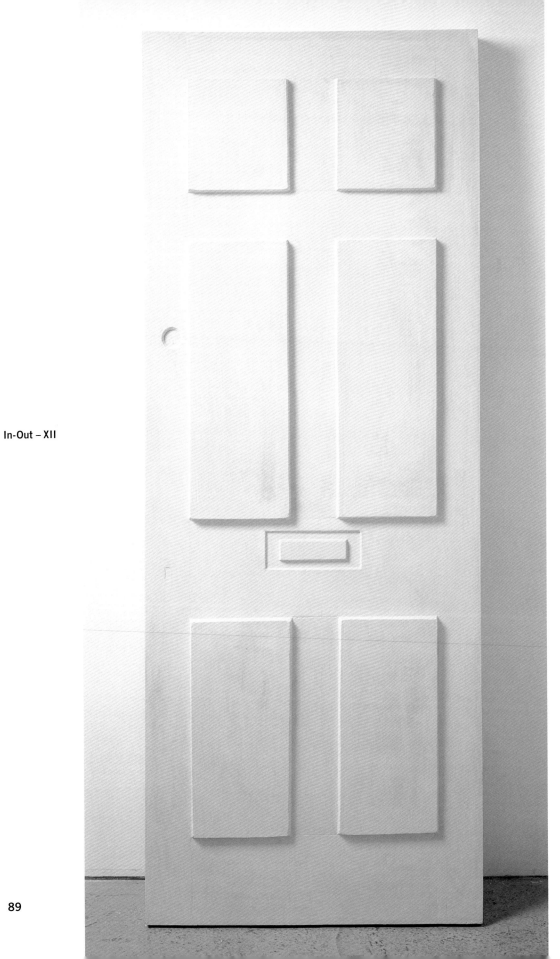

In-Out – XII

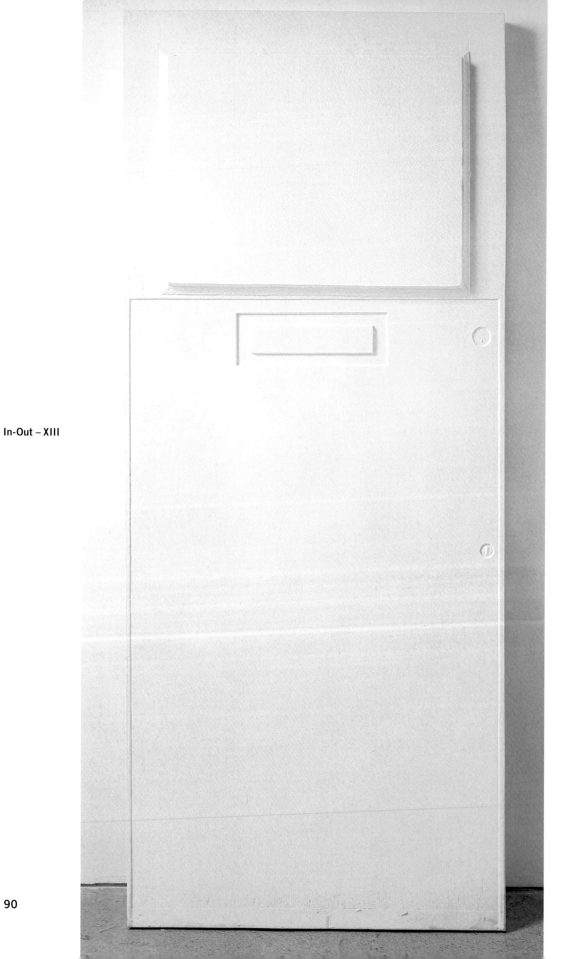

In-Out – XIII

In-Out – XIV

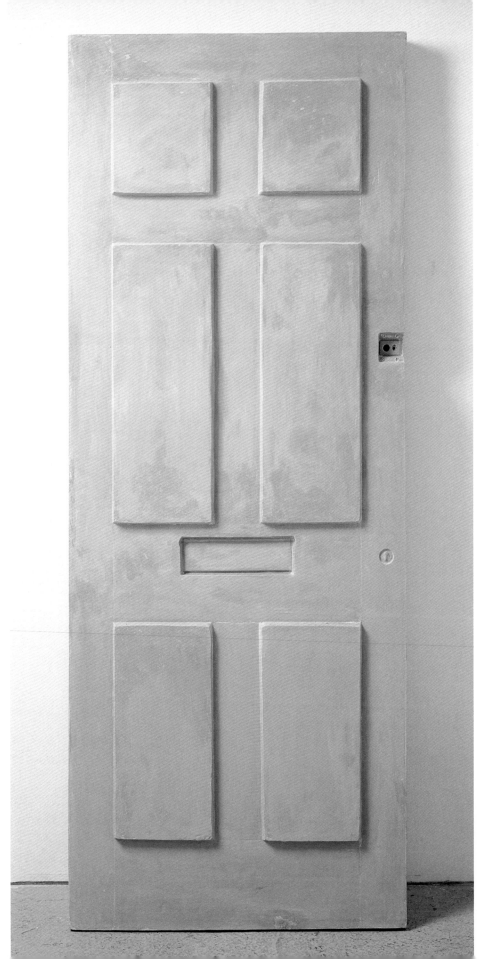

Room 101

Rachel Whiteread und Room 101

Richard Cork

Rachel Whiteread and Room 101

Richard Cork

Als George Orwell den Room 101 zur Hauptbühne seines beängstigenden Romans „1984" machte, schilderte er ihn als einen unheimlichen Raum im gewaltigen ‚Wahrheitsministerium' eines totalitären Regimes, in dem Winston Smith systematisch die Geschichte umzuschreiben hat. Nach seiner Rebellion gegen ‚Big Brother' und das Lügengebäude der Tyrannen wird Smith gefangen genommen, geschlagen, in das unterirdisch gelegene Zimmer 101 gebracht und an einem Stuhl festgeschnallt. O'Brien, der die Verhöre durchführt, eröffnet ihm, dass er dort mit dem „Schrecklichsten von der Welt" konfrontiert werden soll. „Es kann das Lebendig-begraben-Werden sein oder der Tod durch Feuer, durch Ertrinken, durch Pfählung oder fünfzig andere Todesarten." (Vgl. 1984, dt. von Michael Walter, Frankfurt/Main, Berlin 1984, S. 285) Zu seinem blanken Entsetzen findet Smith sich von Ratten in einem in Kopfhöhe platzierten Käfig bedroht.

Die reale Vorlage dieser schrecklichen Folterkammer findet sich im Broadcasting House, der Londoner BBC-Zentrale, wo Orwell im Zweiten Weltkrieg eine Zeit lang in der indischen Abteilung des Eastern Service arbeitete. Für ihn wurde diese Tätigkeit zu einer albtraumhaften Fron. Er verabscheute die öden Abteilungsbesprechungen, und der Raum, in dem sie stattfanden, wurde in seiner rachedurstigen Fantasie zu einem Ort der Angst und Erniedrigung. Als der Zusammenhang zwischen dem Broadcasting House und „1984" erkannt wurde, dürfte die BBC alles andere als erfreut gewesen sein, doch gegen Ende des 20. Jahrhunderts trat Stolz an die Stelle der Peinlichkeit. Orwells Roman war

When George Orwell made Room 101 the focus of his chilling novel '1984', he saw it as an eerie chamber in the gargantuan Ministry of Truth. Here, Winston Smith is employed systematically rewriting history for a totalitarian regime. After rebelling against Big Brother and all the tyrannical lies, Smith is imprisoned, beaten, taken to the subterranean Room 101 and strapped to a chair. As his interrogator O'Brien explains, he would be forced to confront "the worst thing in the world … it may be burial alive, or death by fire, or by drowning, or by impalement, or fifty other deaths." But Smith, to his utter terror, finds himself threatened instead by a cage of rats placed round his head.

The origins of this horrific torture chamber lie in Broadcasting House, the London headquarters of the BBC. During the Second World War Orwell worked there for a while in the Indian section of the Eastern Service. It became, for him, a nightmarish form of drudgery. He abhorred tedious departmental meetings, and the room where they took place was transformed, by his vengeful imagination, into a centre of fear and degradation. The BBC must have been dismayed when it first realised the connection between Broadcasting House and '1984'. But by the time the twentieth century came to an end, embarrassment had given way to pride. Orwells novel was now a classic, admired across the world for its remorseless, apocalyptic indictment of a society dominated by fear, brutality and deceit. So when the BBC started an ambitious Public Art Programme in 2002, curated by Modus Operandi Art Consult-

inzwischen zu einem Klassiker geworden, der in aller Welt als eine schonungslose, apokalyptische Anklage gegen eine von Angst, Brutalität und Täuschung beherrschte Gesellschaft gerühmt wurde. Und als die BBC im Jahr 2002 – „unter dem Leitmotiv ihrer Rolle und ihres Aufgabenbereichs im 21. Jahrhundert" – ein ehrgeiziges, von Modus Operandi Art Consultants kuratiertes „Public Art Programme" in Gang setzte, wurde Rachel Whiteread eingeladen, sich mit dem Zimmer 101 auseinander zu setzen.

Zuerst scheute sie vor dem Gedanken zurück, sich mit einem derart düster aufgeladenen Thema zu befassen. Sie war mit anderen Projekten beschäftigt und ignorierte die ursprüngliche Anfrage. Verständlicherweise hatte Whiteread grundsätzliche Vorbehalte dagegen, in ihrer Kunst die Vorschläge anderer aufzugreifen. Doch dann, nach einiger Zeit, begann sich die Idee in ihr festzusetzen. Als Teenager hatte sie „1984" und Orwells „Farm der Tiere" mit großer Bewunderung gelesen. Sie wuchs in einer sozialistischen Familie auf, und angesichts der Ohnmacht der Arbeiterbewegung während der Regierungszeit Margaret Thatchers in Großbritannien schienen diese beiden Romane nichts von ihrer Relevanz verloren zu haben. Die düstere Unmittelbarkeit Orwells sprach sie an, und sie kann sich noch erinnern, wie sie sich am Neujahrstag des Jahres 1984 vorstellte, dass etwas Schreckliches passieren müsse.

Whiteread entschloss sich, die Einladung der BBC anzunehmen und den originalen Room 101 anzuschauen. Sie kam gerade noch rechtzeitig, denn bald darauf wurde das Zimmer im Rahmen der tiefgreifenden Renovierung des Broadcasting House nach den Plänen von Richard MacCormac zerstört. Zu Whitereads Überraschung war der Raum vollkommen leer – bis auf die Heizungs- und Wasserrohre. Sie glaubte, der Wunsch der BBC wäre es, diese

ants and drawing "inspiration from the BBC's role and remit in the 21st century", it decided to ask Rachel Whiteread if she would tackle Room 101.

At first, she shied away from the thought of making a sculpture from such a grimly loaded subject. Involved with other projects, she ignored the initial request and refused even to think about it. Quite understandably, Whiteread has always harboured reservations about the whole notion of responding, as an artist, to people's suggestions. But then, after a while, the idea began to grow in her mind. As a teenager, she had read '1984' and Orwell's 'Animal Farm' with great admiration. She came from a socialist family, and both these novels seemed very poignant in view of the Labour movements failure during the painfully protracted period when Margaret Thatcher held power in Britain. Growing up in such a context, Whiteread was quick to sense Orwells continuing relevance. She responded to his bleak directness and still recalls imagining, on New Year's Eve in 1984, that something terrible was about to happen.

Before long, therefore, Whiteread decided to take up the BBC's invitation to visit the original Room 101. She was just in time: soon afterwards, it would be demolished as part of Richard MacCormac's major redevelopment of the Broadcasting House site. And to her surprise, Whiteread found that the room was entirely empty – apart from ducts for heating and plumbing. She thought that the BBC wanted her to work with these pipes and tubes. But Whiteread decided instead to strip the room back to its bare bones. She pulled off a lot of loose plaster and, very roughly, filled in the holes. As a result, it resembled a room battered by shrapnel. Whiteread was, of course, quite capable of restoring the interior perfectly before casting began. But,

Rohrleitungen in ihre Arbeit einzubeziehen. Stattdessen jedoch zog sie dem Zimmer sozusagen die Haut ab. Sie entfernte brüchigen Putz und spachtelte die Löcher grob zu. Danach sah das Zimmer aus wie nach einem Schrapnellbeschuss. Selbstverständlich wäre es Whiteread möglich gewesen, die Wände vor dem Abguss wieder perfekt herzurichten, doch zu Orwells Zeiten hatte das Zimmer sicher anders ausgesehen, und eine falsche Rekonstruktion war nicht ihr Ziel.

Wie bei verschiedenen ihrer wichtigsten früheren Arbeiten, so Ghost und House (Abb. S. 112), stellte Whiteread zunächst einen exakten, minuziösen Abguss des gesamten Innenraums her. Fünf Personen waren an diesem komplexen Abgussprozess beteiligt, der sich über sechs Wochen erstreckte. Das Ergebnis ist paradoxerweise präzise und bruchstückhaft zugleich. Die obere Paneelleiste der Täfelung ist nur zur Hälfte vorhanden, und „von Perfektion kann keine Rede sein". Whiteread ist jedoch stolz auf den Abguss, der, wie sie sagt, an Ghost erinnert, tatsächlich jedoch viel robuster ist.

Ihr Room 101 ist zudem viel größer als Ghost, ein Abguss des Innenraums eines beengten Wohnzimmers im Londoner Norden, den die junge Whiteread 1990 schuf. Wie im ursprünglichen Raum im Broadcasting House ragen Fenster aus einer Seite des weißen, gespenstischen Blocks heraus. Jetzt jedoch sehen sie versiegelt aus, als seien sie irgendwann einmal vom Lavastrom eines verheerenden Vulkanausbruchs überflutet worden. Die Skulptur macht einen eiszeitlichen und melancholischen Eindruck. Dennoch betrachtet Whiteread sie nicht als ein finsteres Werk. Hätte sie eine bedrohliche Wirkung erreichen wollen, hätte sie für den Abguss ein anderes – dunkleres und düstereres – Material verwendet. Mit Orwell hat die Skulptur, wie sie sagt, nicht viel zu tun.

realising that the room would have been different in Orwell's day, she had no desire to produce a fake reconstruction.

As in several of Whiteread's most important earlier works, including **Ghost** and **House** (see page 112), she set about producing an elaborate, painstaking cast of the entire interior. The whole complex operation lasted about six weeks and involved five people in the casting process. The outcome, paradoxically, is at once precise and fragmented. She realises that "it only has half a dado rail, and theres nothing perfect about it." But Whiteread feels proud of the casting, and points out

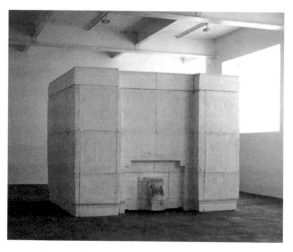

Rachel Whiteread
Ghost 1990
Gips und Stahlgerüst /

Plaster and steel frame
270 x 318 x 365 cm
Gagosian Gallery, London

that "it feels like **Ghost**, but in fact its much more robust."

Her **Room 101** sculpture is also far larger than **Ghost,** which the young Whiteread cast in 1990 from the interior of a cramped North London living-room. Windows jut out from one side of the white, spectral block, just as they did in its original location at Broadcasting House. Now, however, they look sealed up, as if overwhelmed in the past by lava flow from some devastating volcanic eruption. It appears

Es ging ihr um einen authentischen Abguss des Raums, der ihr zu diesem Zweck überlassen wurde. Außerdem kann niemand mit Sicherheit sagen, ob dieser Raum im Broadcasting House tatsächlich mit dem Zimmer 101 der Kriegsjahre identisch war. „Es ist ein Fake 101, wie all die flüsternden Flure im BBC-Haus. Ich war mir nicht sicher, ob ich die Skulptur überhaupt ‚Room 101' nennen sollte."

Schließlich gab sie dieser grandiosen Skulptur den Titel Untitled (Room 101). Deren majestätische Größe trat besonders deutlich hervor, als sie – eine verblüffende und weitsichtige Entscheidung – für eine gewisse Zeit im Victoria & Albert Museum ausgestellt wurde. In einem der riesigen Höfe, in denen Gipsabgüsse herausragender Skulpturen früherer Jahrhunderte präsentiert werden, stand sie in einem dramatischen Kontrast zu diesen Plastiken. Whiteread hatte diese neu arrangiert, um Platz für den Eindringling zu schaffen und um eine spannungsreiche Begegnung zwischen Untitled (Room 101) und einigen der bedeutendsten Skulpturen von Renaissancebildhauern zu inszenieren. Auf einer Seite starrte Verrocchios behelmtes Haupt des Condottiere Colleoni den weißen Fremdling wie entgeistert an. Mit weit aufgerissenen Augen und sich furchender, drohender Stirn schien er seinen Truppen den Befehl geben zu wollen, ihn anzugreifen und zu zermalmen. Ich musste bei diesem Anblick an den banausischen Kommunalstadtrat von East London denken, der vor einem Jahrzehnt die unverzeihliche Anordnung gab, Whiteareads Meisterwerk House dem Erdboden gleichzumachen und spurlos verschwinden zu lassen. Die Erinnerung an diesen mutwilligen Akt der Barbarei ist nach wie vor erschreckend, zumal House auf eine Art der Versuch war, der Nachwelt ein Gebäude zu erhalten, das ansonsten im Rahmen der Sanierung des Areals verschwunden wäre. Insofern war ich begeistert, als ich

glacial and melancholy, yet she does not see the sculpture as a sinister work. If Whiteread had been bent on making it seem ominous, she would have cast it in a different material – darker and gloomier. Instead, wanting it to be a direct cast of the actual space at her disposal, she does not regard the sculpture "as a great deal to do with Orwell." After all, nobody knows for certain if the room Whiteread saw at Broadcasting House was the real Room 101. "Its a fake 101," she said,"just like the whispering corridors of the BBC. In fact, I wondered whether to call it Room 101 at all."

In the event, Whiteread called this magisterial sculpture **Untitled (Room 101)**. And it was given even greater resonance by the surprising yet inspired decision to install it, temporarily, in the Victoria & Albert Museum. There, in one of the vast courts housing plaster casts of landmark sculpture from previous centuries, her imposing work was dramatically contrasted with the images surrounding it. Whiteread rearranged them, partly to accommodate her intrusion and partly to stage an intense encounter between **Untitled (Room 101)** and some of the greatest figures produced by Renaissance sculptors. On one side, Verrocchio's helmeted head of the ferocious mercenary leader Colleoni stared at Whitereads white invader as if aghast. With enormously widened eyes and menacing brows furrowed, he seemed on the point of ordering his troops to attack her offensive sculpture and pulverise it. He triggered a recollection in my mind of the philistine local councillor in East London who gave the unforgiveable order, just over a decade ago, to bulldoze her masterpiece 'House' and erase all trace of it from the city street. The memory of that wanton obliteration still seems appalling, especially since **House** was on one level an attempt to preserve and memorialise a building that would otherwise have vanished

hörte, dass Whiteread den Room 101 bewahren wollte, als sie bei ihrem Besuch im Broadcasting House von seiner bevorstehenden Zerstörung erfuhr.

Die gespenstische Präsenz von Untitled (Room 101) ist allerdings alles andere als besänftigend. Im Skulpturenhof des Victoria & Albert Museums ging von diesem Werk eine derart verunsichernde Wirkung aus, dass selbst die robustesten Figuren Michelangelos vor ihm zurückzuschrecken schienen. Sowohl der Rebellische Sklave als auch der Sterbende Sklave schienen sich wie unter Schock krümmend und windend dem fremdartigen Eindringling entziehen zu wollen. Und der Abguss der Kolossalstatue Michelangelos, des David, ragte hoch oberhalb der Whiteread'schen Skulptur empor und wandte sein Gesicht ab wie ein herrischer Monarch, der einen unwillkommenen Besucher ignoriert.

Whiteread war erfreut, eine so gewichtige, faszinierende Konfrontation zwischen ihrem Werk und so vielen historischen Ikonen im Bereich der Skulptur arrangieren zu können. Die Aufstellung musste in kürzester Zeit geschehen, und das Personal des Victoria & Albert Museums war „sehr entgegenkommend. Die Architekturgalerie wäre mir als Standort zwar lieber gewesen, doch das war nicht möglich". So hatte sie nichts dagegen, Untitled (Room 101) inmitten dieser Figuren zu präsentieren. „Der Sterbende Sklave ist eine sehr erotische Skulptur, und mein Werk sieht in diesem Kontext so aus, als ob die Raum-Zeit-Maschine gelandet wäre." Whiteread fühlte sich in diesem Teil des Victoria & Albert Museums ganz zu Hause. Als Studentin der Slade School of Fine Art hatte sie in den 1980er Jahren die Skulpturenhöfe häufig besucht. Sie war von Anfang an vom Abgussverfahren fasziniert, und hier hatte sie die Gelegenheit, die Oberflächen der ausgestellten Gipsabgüsse und deren atemberaubende

in the redevelopment of the area. In this respect, I was fascinated to hear Whiteread recalling how, when she visited Room 101 at Broadcasting House and heard that "it was being demolished, I felt an urgency to keep it."

There is, however, nothing remotely reassuring about the spectral presence of **Untitled (Room 101)**. In the sculpture court of the Victoria & Albert Museum, its effect was so unsettling that even the most robust and sinewy of Michelangelo's figures appeared to recoil from its advent among them. Both the **Rebellious Slave** and the **Dying Slave** seemed to be in shock, twisting and writhing as they strove to evade any involvement with the alien intruder. As for the cast of Michelangelo's ultimate colossus, **David**, he towered far above Whiteread's sculpture and turned his face away, like an imperious monarch pretending that an unwelcome visitor simply did not exist. Whiteread was delighted by the opportunity to set up such a momentous, mesmerising confrontation between her work and so many iconic figures from the past. It all happened at very short notice, and the staff of the Victoria & Albert Museum were in her view "incredibly accommodating. I would have preferred it to go on display in the architectural gallery, but we couldn't do it." She had no regrets about placing **Untitled (Room 101)** among "all these amazing figures. The 'Dying Slave' is a very erotic piece of sculpture, and in this context my work looks like the Tardis has landed." However science-fiction this bizarre location may appear to her, Whiteread felt completely at home in this part of the Victoria & Albert Museum. When a student at the Slade School of Fine Art in the 1980's, she used to visit the Cast Courts a great deal. Intrigued by the casting process, Whiteread also relished the opportunity to examine the surface of the sculpture on display and their

Dimensionen zu studieren. Insbesondere die Monumentalität der Trajanssäule versetzte sie immer wieder in Erstaunen.

Von der Empore aus betrachtet, trat das strahlende Weiß von Untitled (Room 101) noch deutlicher in Erscheinung. Im Vergleich zu den stumpferen Tönen der älteren Gipsabgüsse rundum machte das Werk einen auffällig leuchtenden und makellosen Eindruck. Wer ohne Vorwarnung plötzlich davor stand, musste erschrecken. Kein Besucher konnte damit rechnen, in den Skulpturenhöfen auf zeitgenössische Kunst zu stoßen, und Whiteread wollte den Überraschungseffekt und das Geheimnisvolle der Präsentation unbedingt erhalten. Als das Museum entschied, Videomonitore und ausführliche schriftliche Erläuterungen zu installieren, widersetzte sie sich mit Erfolg. Die modernen Präsentationen im benachbarten Naturhistorischem Museum hält sie für deprimierend: „Die Technologie kann den Blick auf das verstellen, was an gewaltigen Örtlichkeiten wie den Skulpturenhöfen mit ihren wahrhaft epischen Dimensionen tatsächlich erstaunlich ist." Die Entscheidung des Victoria & Albert Museums, diesen Höfen ihre ursprüngliche rote und grüne Farbe zurückzugeben, findet Whitereads Zustimmung.

Untitled (Room 101) hatte fast ihr ganzes Atelier in Beschlag genommen, sodass „ich fast nichts anderes dort tun konnte". Zu Whitereads Verblüffung wirkte das monumentale Werk im Victoria & Albert Museum wie eine Streichholzschachtel. Zugleich übte es jedoch, wie sie glaubte, unter den figurativen Gipsabgüssen eine sehr gespenstische Wirkung aus. Zwischen ihrem Werk und diesen Skulpturen gab es einen Dialog, und ging man abends durch die Skulpturenhöfe, „konnte einem schon schaurig zumute werden".

In meinen Augen ließ Whitereads Skulptur vor allem an den Zweiten Weltkrieg denken. Wenn

breathtaking scale. In particular, she found the monumentality of Trajan's Column astounding to contemplate.

Viewed from the balcony above, the gleaming whiteness of **Untitled (Room 101)** became even more apparent. It looked strikingly luminous and pristine compared with the duller hues of the older sculpture nearby. Visitors who stumbled across it without warning were bound to feel startled. After all, the Cast Courts are not a place where anyone normally expects to discover contemporary art, and Whiteread was determined to retain a sense of mystery and surprise. At one stage, the Victoria & Albert Museum staff told her that they wanted to instal video monitors and elaborate verbal explanations. But Whiteread successfully resisted the idea. She considers that the modern displays next door at the Natural History Museum are depressing: "technology can get in the way of what's truly astonishing about enormous places like the Cast Courts." They are indeed built on an epic scale, and she approves of the Victoria & Albert's decision to set about restoring them back to their original red and green colours.

Having been accustomed to seeing **Untitled (Room 101)** in her studio, where "it looked so big that I could not do anything else there," Whiteread was taken aback to find that in the Victoria & Albert Museum it looked "like a matchbox." But she also believed that it had "a very ghostly effect in among the figurative pieces. There's a dialogue between them, and if you walked round the Cast Courts at night it could be incredibly creepy."

To my eyes, Whiteread's sculpture was redolent above all of the Second World War. As I walked round this squat, looming hulk, made in elegiac remembrance of a space no longer there, it seemed akin to the forbidding structures erected on Britain's coastline during

ich um diesen gedrungenen, dräuenden Koloss herumging, diese elegische Reminiszenz an einen nicht mehr vorhandenen Raum, wurde ich an die abschreckenden Bauten erinnert, die in den 1940er Jahren an der britischen Küste errichtet worden waren: an Bunker, Unterstände und Wachposten, von denen aus der Horizont nach Anzeichen für einen Angriff des Feindes abgesucht wurde und die zugleich etwas Festungsartiges hatten. Die über die ganze Oberfläche des Werks verstreuten, auf die zahllosen Löcher in den Wänden von Room 101 zurückgehenden Brocken vermitteln den Eindruck, Untitled (Room 101) habe die Bombenangriffe des Blitzkrieges erlitten.

Diese Assoziationen sind alles andere als weit hergeholt: Orwell arbeitete im Zweiten Weltkrieg für die BBC und schrieb kurz darauf den Roman „1984". Whiteread ist der Überzeugung, dass in der Skulptur viele historische Schichten übereinander lagern, doch vor allem scheint sie an die traumatische Zeit zu gemahnen, als Großbritannien zusammen mit anderen Nationen Gefahr lief, der Aggression des denkbar skrupellosesten Feindes zu unterliegen. Aus diesem Grund sollte Untitled (Room 101) dauerhaft in der Öffentlichkeit präsentiert werden, entweder in der BBC oder an einem anderen angemessenen Ort. Jeder sollte die Möglichkeit haben, dieses eindringliche Monument zu betrachten und seine ständig aktuelle Warnung vor den Gefahren der Täuschung, der Tyrannei und der Terrorherrschaft zu beherzigen.

Alle Zitate aus einem Interview mit Rachel Whiteread, **London, 24. September 2003.**

the 1940s. Pillboxes, bunkers and look-out posts came to my mind, all scanning the horizon for signs of enemy attack and, at the same time, asserting the ability to be fortress-like in defence. The lumps peppering the surface of Whiteread's work, all the way round, add to the feeling that it has been under siege. Created by the myriad cavities in the original Room 101, they look like damage inflicted on a building by bomb-raids in the Blitz.

Since Orwell worked for the BBC during the war, and wrote '1984' soon afterwards, these associations seem overwhelmingly apt. Whiteread believes that the sculpture possesses "layer upon layer of history," but it appears above all to memorialise the traumatic period when Britain, along with so many nations elsewhere in the world, very nearly succumbed to enemy aggression of the most ruthless, savage kind. That is why **Untitled (Room 101)** should ideally be on permanent public view, either at the BBC or in another, equally appropriate location. Everyone should be able to view this haunting monument, and heed its timely warning about the dangers of deception, tyranny and the rule of terror.

All quotations from an interview with **Rachel Whiteread,** London, September 24, 2003.

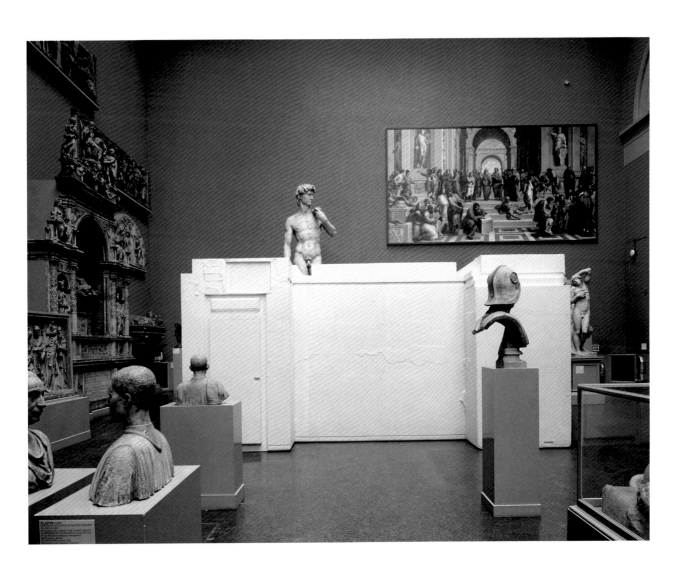

Untitled (Room 101) 2003
Mischtechnik / Mixed media
300 x 500 x 643 cm
Courtesy of the artist and Gagosian Gallery

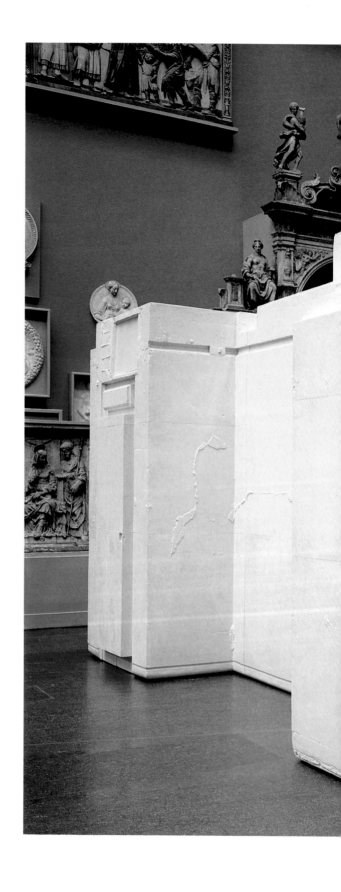

Untitled (Room 101) 2003

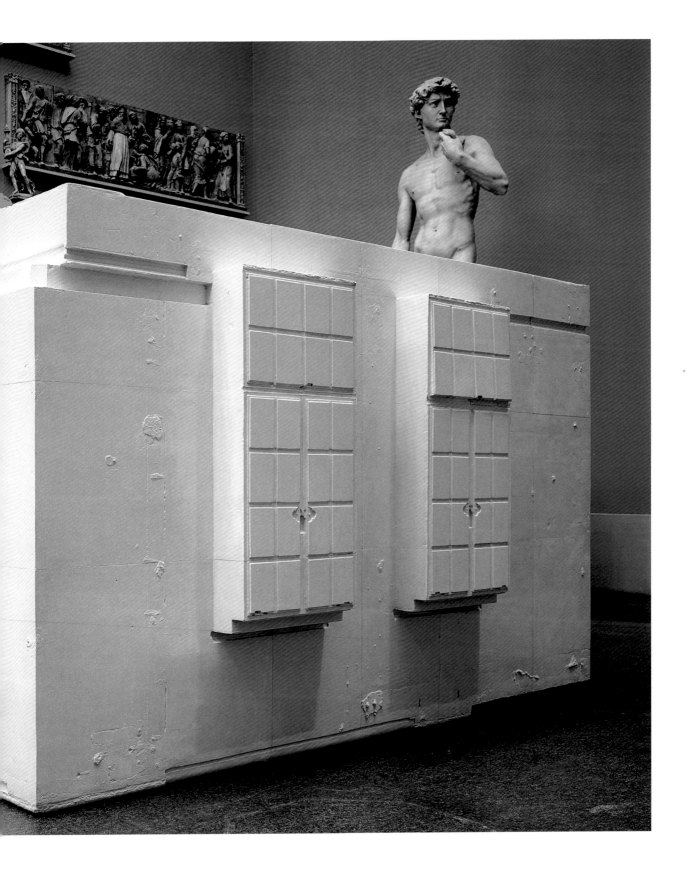

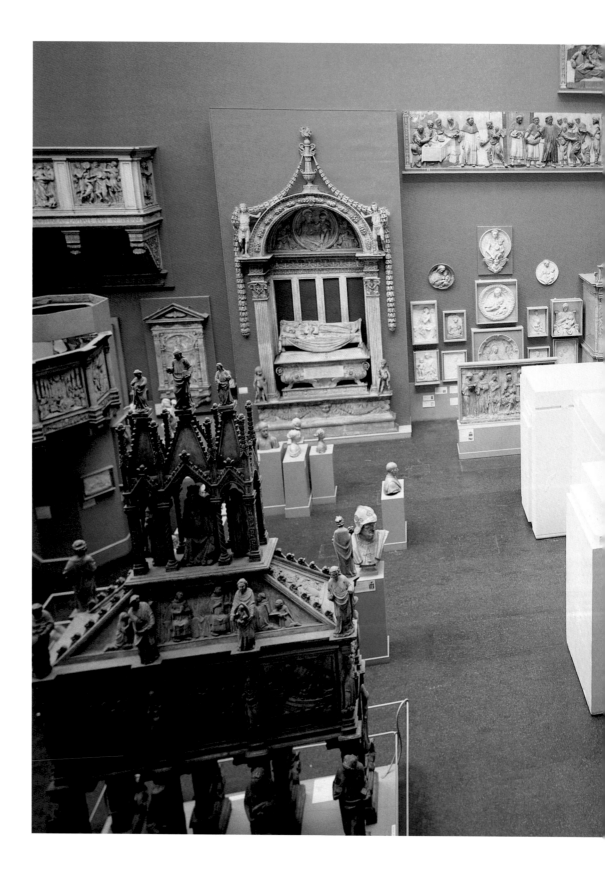

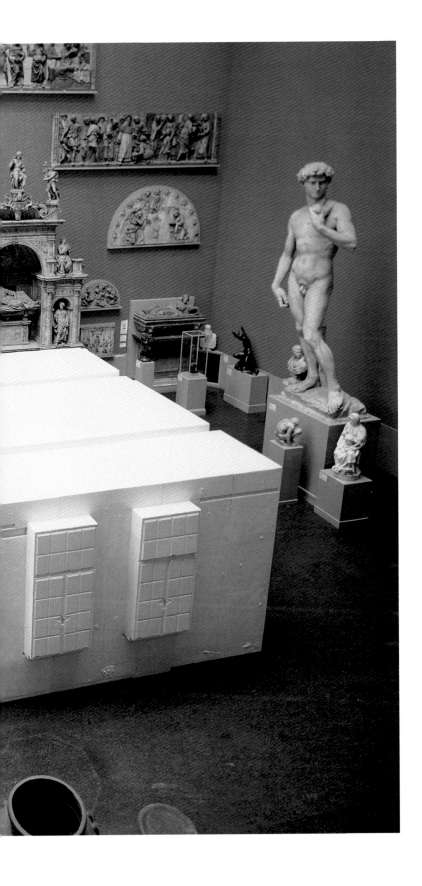

Untitled (Room 101) 2003

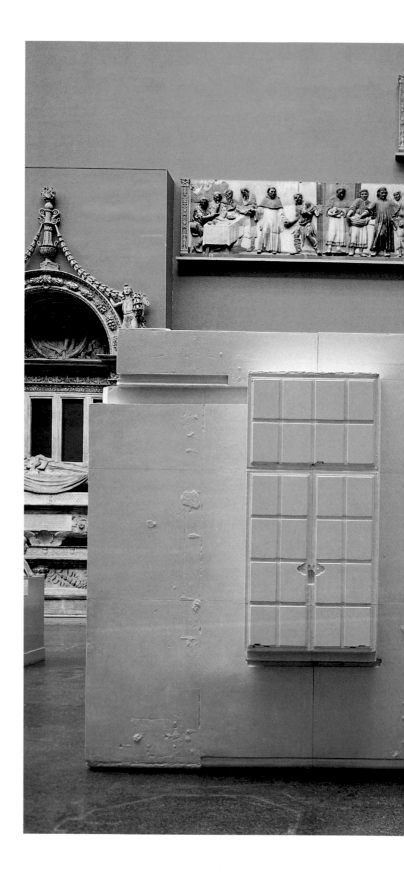

Untitled (Room 101) 2003

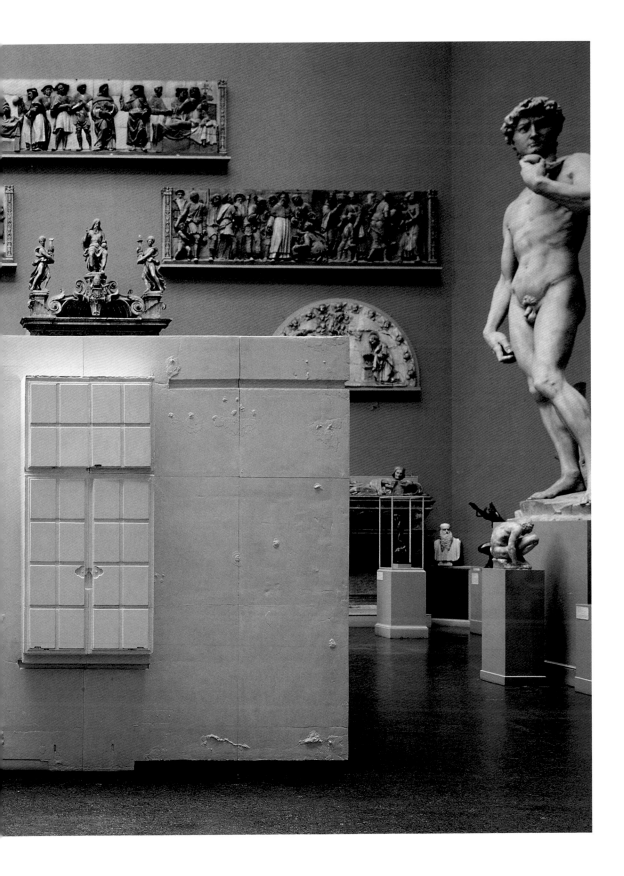

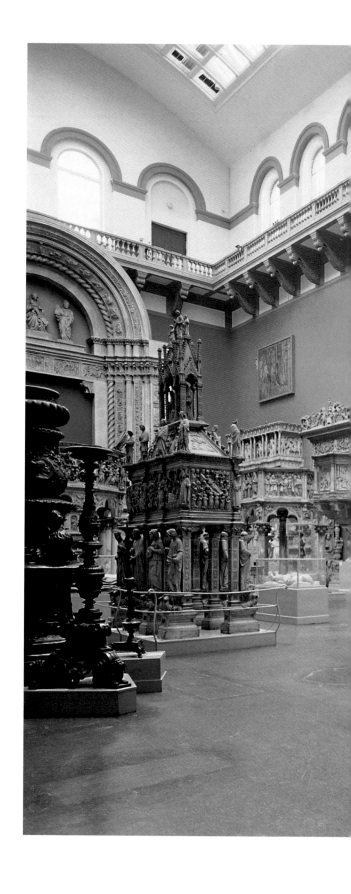

Untitled (Room 101) 2003

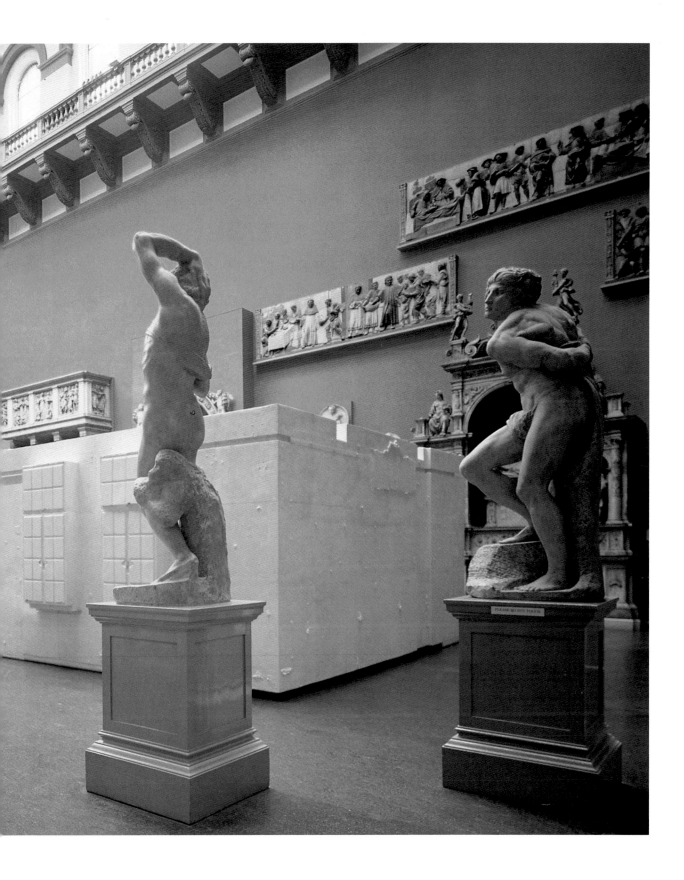

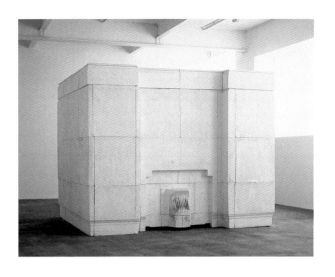

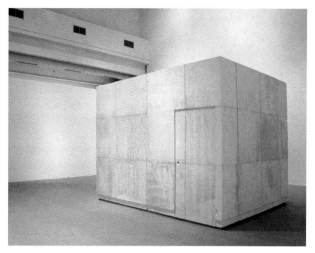

Ghost 1990
Gips und Stahlgerüst / Plaster and steel frame
270 x 318 x 365 cm

Untitled (Room) 1993
Gips / Plaster
275 x 300 x 350 cm

Untitled (Basement) 2001
Mischtechnik / Mixed media
325 x 658 x 367 cm

Untitled (Stairs) 2001
Mischtechnik / Mixed media
375 x 550 x 220 cm

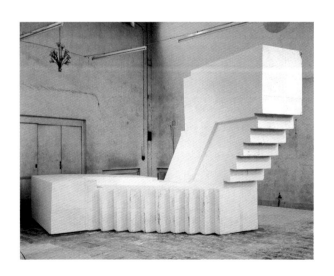

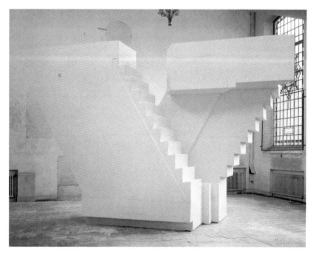

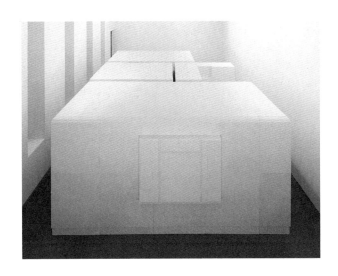

Untitled (Apartment) 2001
Mischtechnik / Mixed media
285 x 1109 x 614 cm

Untitled (Rooms) 2001
Mischtechnik / Mixed media
keine Maßangaben / no dimensions data

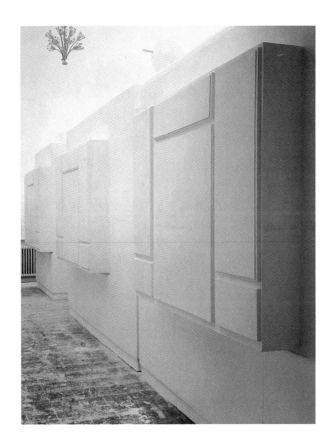

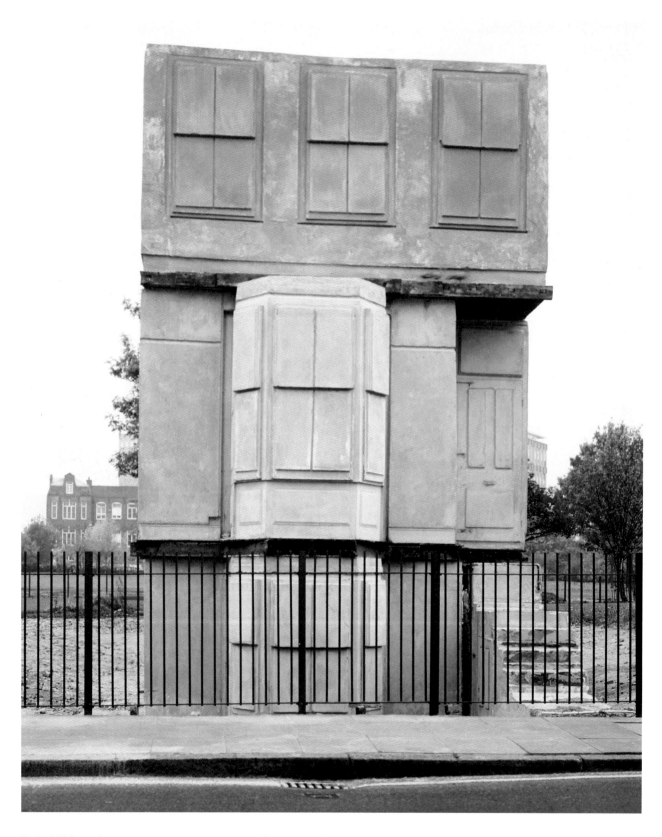

Rachel Whiteread
Untitled (House) 1993

Beton, Holz, Stahl / Concrete, wood, steel
zerstört / destroyed 1994
in Auftrag gegeben / commissioned by Artangle
unterstützt / sponsored by Beck's

Ausgestellte Arbeiten

Exhibited Works

Erdgeschoss / Ground Floor

Untitled (Upstairs) 2000/2001
Mischtechnik / Mixed media
550 x 330 x 570 cm
Courtesy of the artist and
Gagosian Gallery

1. Stock / First Floor

Untitled (Bronze Floor)
1999/2000
Bronze, patiniert / Patinated bronze
98 Einheiten / units,
je / each 50 x 50 cm;
gesamt / overall 350 x 700 cm
Courtesy of the artist and
Luhring Augustine, New York

Untitled (Cast Iron Floor) 2001
Gusseisen, schwarz patiniert /
Cast iron and black patina
99 Einheiten / units
1 x 502 x 414 cm
Courtesy of the artist and
Luhring Augustine, New York

Untitled Floor (Thirty-Six) 2002
Aluminiumguss / Cast aluminium
36 Fliesen / tiles,
je / each 68 x 68 cm;
gesamt / overall
407 x 407 x 2,75 cm
Courtesy of the artist and
Luhring Augustine, New York

2. Stock / Second Floor

In-Out – I 2004
Plastifizierter Gips mit inwendigem
Aluminiumgerüst / Plasticised
plaster with interior aluminium
framework
201 x 80 x 9 cm
Privatsammlung / Private Collection
Courtesy Gagosian Gallery

In-Out – II 2004
Plastifizierter Gips mit inwendigem
Aluminiumgerüst / Plasticised
plaster with interior aluminium
framework
201 x 80 x 9 cm
Privatsammlung / Private Collection,
Los Angeles
Courtesy Luhring Augustine,
New York

In-Out – III 2004
Plastifizierter Gips mit inwendigem
Aluminiumgerüst / Plasticised
plaster with interior aluminium
framework
197 x 76 x 10 cm
Courtesy of the artist and
Luhring Augustine, New York

In-Out – IV 2004
Plastifizierter Gips mit inwendigem
Aluminiumgerüst / Plasticised
plaster with interior aluminium
framework
197 x 76 x 10 cm
Privatsammlung / Private Collection

In-Out – V 2004
Plastifizierter Gips mit inwendigem
Aluminiumgerüst / Plasticised
plaster with interior aluminium
framework
191 x 75 x 14 cm
Courtesy of the artist and
Luhring Augustine, New York

In-Out – VI 2004
Plastifizierter Gips mit inwendigem
Aluminiumgerüst / Plasticised
plaster with interior aluminium
framework
202 x 79 x 10 cm
Courtesy of the artist and
Luhring Augustine, New York

In-Out – VII 2004
Plastifizierter Gips mit inwendigem
Aluminiumgerüst / Plasticised
plaster with interior aluminium
framework
215 x 91 x 11 cm
Collection of Stanley and
Gail Hollander, Los Angeles
Courtesy Gagosian Gallery

In-Out – VIII 2004
Plastifizierter Gips mit inwendigem
Aluminiumgerüst / Plasticised
plaster with interior aluminium
framework
197 x 86 x 10 cm
Courtesy of the artist and
Luhring Augustine, New York

In-Out – IX 2004
Plastifizierter Gips mit inwendigem
Aluminiumgerüst / Plasticised
plaster with interior aluminium
framework
219 x 91 x 10 cm
Courtesy of the artist and Luhring
Augustine, New York

In-Out – X 2004
Plastifizierter Gips mit inwendigem
Aluminiumgerüst / Plasticised
plaster with interior aluminium
framework
213 x 91 x 10,5 cm
Privatsammlung / Private Collection
Courtesy Gagosian Gallery

In-Out – XI 2004
Plastifizierter Gips mit inwendigem
Aluminiumgerüst / Plasticised
plaster with interior aluminium
framework
197 x 75 x 13,5 cm
Courtesy of the artist and
Luhring Augustine, New York

In-Out – XII 2004
Plastifizierter Gips mit inwendigem
Aluminiumgerüst / Plasticised
plaster with interior aluminium
framework
197 x 76 x 10 cm
Privatsammlung /
Private Collection

In-Out – XIII 2004
Plastifizierter Gips mit inwendigem
Aluminiumgerüst / Plasticised
plaster with interior aluminium
framework
215 x 91 x 11 cm
Privatsammlung / Private Collection
Courtesy Gagosian Gallery

In-Out – XIV 2004
Plastifizierter Gips mit inwendigem
Aluminiumgerüst / Plasticised
plaster with interior aluminium
framework
197 x 76 x 10 cm
Peter Freeman, Inc., New York

Untitled (Room 101) 2003
Mischtechnik / Mixed media
300 x 500 x 643 cm
Courtesy of the artist and
Gagosian Gallery

Werkfamilien

Families of Works

Treppen / Stairs

Untitled (Upstairs) 2000/2001
Mischtechnik / Mixed media
550 x 330 x 570 cm

Untitled (Fire Escape) 2002
Mischtechnik / Mixed media
736 x 547 x 600,5 cm

Untitled (Domestic) 2002
Mischtechnik / Mixed media
676 x 584 x 245 cm

Bodenstücke / Floors

Untitled (Floor, Small) 1992
Gips / Plaster
24,2 x 91,4 x 86,4 cm

Untitled (Floor) 1992
Gips / Plaster
24,1 x 280,7 x 622,3 cm

Untitled (Wax Floor) 1992
Wachs und Polystyrol /
Wax and polystyrene
28 x 100 x 465 cm

Untitled (Platform) 1992
Gips und Polystyrol /
Plaster and polystyrene
28 x 157 x 326 cm

Untitled (Amber Floor) 1993
Gummi / Rubber
2 x 86 x 245 cm

Untitled (Ceiling Floor Piece) 1993
Gummi / Rubber
2 Teile / units, 12 x 140 x 120 cm
und / and 2,5 x 140 x 120 cm

Untitled (Rubber Floor) 1993
Gummiabguss / Cast rubber
2 x 29 x 124 cm

Untitled (Floor) 1994/95
Kunstharz / Resin
25,4 x 22,9 x 33 cm

Untitled (Resin Corridor) 1995
Kunstharz / Resin
389 x 136 x 21,5 cm

Felt Floor 1997
100-prozentig reine Wolle,
Kunstharz / 100% virgin wool
impregnated with resin
18 Teile / units, je / each
137,2 x 45,7 x 7,6 cm

Untitled (Bronze Floor) 1999/2000
Bronze, patiniert / Patinated bronze
98 Teile / units, je / each 50 x 50 cm;
overall 700 x 350 cm

Untitled (Cast Corridor) 2000
Eisenabguss / Cast iron
24 Teile / units, gesamt / overall
1,58 x 226 x 405 cm

Untitled (Cast Iron Floor) 2001
Eisenabguss, schwarz patiniert /
Cast iron and black patina
99 Teile / units, je / each 1 x 46 x 46 cm;
gesamt / overall, 1 x 502 x 411 cm

Untitled Floor (Twenty-Five) 2002
Aluminiumabguss / Cast aluminium
339 x 339 x 2,75 cm

Untitled Floor (Thirty-Six) 2002
Aluminiumguss / Cast aluminium
36 Fliesen / tiles,
je / each 68 x 68 cm; gesamt / overall
407 x 407 x 2,75 cm

Räume / Rooms

Ghost 1990
Gips und Stahlgerüst /
Plaster and steel frame
270 x 318 x 365 cm

Untitled (Room) 1993
Gips / Plaster
275 x 300 x 350 cm

Untitled (House) 1993
Beton, Holz, Stahl /
Concrete, wood, steel
zerstört / destroyed 1994
in Auftrag gegeben /
commissioned by Artangle
unterstützt / sponsored by Beck's

**Holocaust-Mahnmal /
Holocaust Memorial** 1995/2000
Mischtechnik / Mixed media
390 x 752 x 1058 cm
Wien / Vienna

Untitled (Basement) 2001
Mischtechnik / Mixed media
325 x 658 x 367 cm

Untitled (Apartment) 2001
Mischtechnik / Mixed media
285 x 1109 x 614 cm

Untitled (Stairs) 2001
Mischtechnik / Mixed media
375 x 550 x 220 cm

Untitled (Rooms) 2001
Mischtechnik / Mixed media
keine Maßangaben /
no dimensions data

Untitled (Room 101) 2003
Mischtechnik / Mixed media
etwa / approx. 3 x 5 x 6,43 m

Rachel Whiteread

1963
geboren / born in London
lebt und arbeitet / lives and works
in London

Ausbildung / Education

1982–85
Brighton Polytechnic – Malerei /
Painting BA

1985–87
Slade School of Fine Art –
Bildhauerei / Sculpture MA

Einzelausstellungen (Auswahl) /
Selected Solo Exhibitions

2005
Rachel Whiteread,
Walls, Doors, Floors and Stairs,
Kunsthaus Bregenz

2004
Rachel Whiteread,
Museu de Arte Moderna,
Rio de Janeiro; Museu de Arte
Moderna, São Paulo

2003
Room 101,
Victoria & Albert Museum,
London
Rachel Whiteread,
Koyanagi Gallery, Tokyo
Rachel Whiteread,
Luhring Augustine Gallery,
New York

2002
Rachel Whiteread, Haunch
of Venison Gallery, London

2001
Monument, Fourth Plinth Project,
Trafalgar Square, London
Rachel Whiteread, Serpentine
Gallery, London; Scottish National
Gallery of Modern Art, Edinburgh
Rachel Whiteread: Transient Spaces,
Deutsche Guggenheim, Berlin; The
Solomon Guggenheim Museum, New
York (2002)

2000
Holocaust Memorial,
Judenplatz, Wien / Vienna

1999
Rachel Whiteread, Luhring
Augustine Gallery, New York

1998
Water Tower Project,
Public Art Fund, New York
Rachel Whiteread,
Anthony d'Offay Gallery, London

1997
Rachel Whiteread, Palacio de
Velázquez, Museo Nacional Centro
de Arte Reina Sofía, Madrid
(kuratiert von / curated by Michael
Tarantino)
British Pavilion, XLVII Biennale
di Venezia

1996
Rachel Whiteread: Demolished,
Karsten Schubert Ltd, London
(in Zusammenarbeit mit /
in collaboration with Charles Booth-
Clibborn)
Rachel Whiteread: Sculptures,
Luhring Augustine Gallery,
New York

Rachel Whiteread: Skulpturen /
Sculptures 1988–1996, Max
Gandolph-Bibliothek, Salzburg;
Herbert von Karajan Centrum,
Wien / Vienna
Rachel Whiteread: Shedding Life,
Tate Gallery, Liverpool

1995
Rachel Whiteread: Sculptures,
British School at Rome
Rachel Whiteread: Untitled (Floor),
Karsten Schubert Ltd, London

1994
Rachel Whiteread:
Arbeiten auf Papier / Works on
paper, Galerie Aurel Scheibler,
Köln / Cologne
Rachel Whiteread: Skulpturen /
Sculptures, Kunsthalle Basel;
Institute of Contemporary Art,
Philadelphia; Institute of
Contemporary Art, Boston
Rachel Whiteread: Drawings,
Luhring Augustine Gallery, New York

1993
Galerie Claire Burrus, Paris
Rachel Whiteread: Sculptures,
Museum of Contemporary Art,
Chicago
House, Auftragsarbeit für /
commissioned by Artangel Trust
and Beck's, London
Rachel Whiteread: Zeichnungen,
DAAD-Galerie, Berlin

1992
Rachel Whiteread: Recent Sculpture,
Luhring Augustine Gallery, New York
Rachel Whiteread: Sculptures,
Sala Montcada de la Fundació 'la
Caixa', Barcelona
Rachel Whiteread: Sculptures
1990–1992, Stedelijk Van
Abbemuseum, Eindhoven

1991
Arnolfini Gallery, Bristol
Rachel Whiteread: Sculptures,
Karsten Schubert Ltd, London

1990
Ghost, Chisenhale Gallery, London

1988
Carlisle Gallery, London

Gruppenausstellungen (Auswahl) /
Selected Group Exhibitions

2004
Design is not Art, Cooper-Hewitt,
National Design Museum
(Smithsonian), New York; Aspen Art
Museum (2005)
After Images – Kunst als soziales
Gewissen, Neues Museum
Weserburg, Bremen
The Snow Show, Lappland / Lapland
Drawings, Gagosian Gallery, London
Matisse to Freud: A Critic's Choice,
British Museum, London
Female Identities? – Künstlerinnen
der Sammlung Goetz, Neues
Museum Weserburg, Bremen

2003
Days like these, Tate Britain, London
Bull's Eyes, Arken Museum,
Kopenhagen / Copenhagen

2002
Conversation?: Recent acquisitions
of the Van Abbemuseum,
The Factory, Academy of Fine Arts,
Athen / Athens
The Physical World: An exhibition
of painting and sculpture,
Gagosian Gallery, New York
Thinking Big: Concepts for 21st
century British sculpture,
Peggy Guggenheim Collection,
Venedig / Venice
Blast to Freeze: British Art in the
20th century, Kunstmuseum
Wolfsburg; Les Abattoirs, Toulouse
Wall & Whiteread, Kukje Gallery,
Seoul
To be Looked At, Collection,
The Museum of Modern Art,
Queens, New York
Sphere: Loans from the invisible
Museum, Sir John Soane's Museum,
London

2001
Century City, Tate Modern, London
Lost & Found 2,
Kulturhuset, Stockholm
Double Vision, Galerie für Zeit-
genössische Kunst, Leipzig
Public Offerings, Museum of
Contemporary Art, Los Angeles

2000
Sincerely Yours, Astrup Fearnley
Museum of Modern Art, Oslo
Le Temps Vite, Musée national d'art
moderne, Centre Georges Pompidou,
Paris
Ant Noises, The Saatchi Collection,
London
L'Ombra della Ragione: L'idea del
sacro nel' Identità Europea, La
Galleria d'Arte Moderna, Bologna

Between Cinema and a Hard Place,
Tate Modern, London
Amnesia, Neues Museum
Weserburg, Bremen
Open Ends: 11 Exhibitions of
Contemporary Art from 1960 to
Now, The Museum of Modern Art,
New York

1999
Le Musée a l'heure anglaise:
Sculptures de la collection du
British Council 1965–1998, Musée
des Beaux-Arts de Valenciennes
House of Sculpture, Modern Art
Museum of Fort Worth, Texas; Museo
de Arte Contemporáneo de
Monterrey, Mexiko / México (kura-
tiert von / curated by Michael
Auping)
Sensation, Brooklyn Museum of Art,
Brooklyn, New York

1998
Displacements: Miroslaw Balka,
Doris Salcedo, Rachel Whiteread,
Art Gallery of Ontario, Toronto
REAL/LIFE: New British Art, Tochigi
Prefectural Museum of Fine Arts;
Fukuoka Art Museum; Hiroshima
City Museum of Contemporary Art;
Tokyo Museum of Contemporary Art;
Ashiya City Museum of Art & History
Milestones in British Sculpture,
Skulptur im Schlosspark Ambras,
Tirol
Fifty Years of British Sculpture,
NatWest Group Art Collection,
London
Family, Nvisible Museum,
Edinburgh
Thinking Aloud, Kettle's Yard,
Cambridge; Cornerhouse,
Manchester; Camden Arts Centre,
London

1997
Sensation: Young British Artists from The Saatchi Collection, Royal Academy of Arts, London; Neue Nationalgalerie im Hamburger Bahnhof, Berlin
Art from the UK: Rachel Whiteread, Abigail Lane, Douglas Gordon, Sammlung Goetz, München / Munich

1996
Bild-Skulpturen – Skulpturen-Bild: Neuere Aspekte plastischer Kunst in der Sammlung Jung, Suermondt-Ludwig Museum, Aachen
Un siècle de sculpture anglaise, Galerie Nationale du Jeu de Paume, Paris
Distemper: Dissonant Themes in the Art of the 1990s, Hirshhorn Museum and Sculpture Garden, Washington

1995
Five Rooms: Richard Hamilton, Reinhard Mucha, Bruce Nauman, Bill Viola & Rachel Whiteread, Anthony d'Offay Gallery, London
British Art of the 80s and 90s: The Weltkunst Collection, Irish Museum of Modern Art, Dublin
British Contemporary Sculpture: From Henry Moore to the 90s, Auditorio de Galicia, Santiago de Compostela; Fundaçao de Serralves, Porto
Here & Now, Serpentine Gallery, London
Brilliant: New Art from London, Walker Art Centre, Minneapolis; Contemporary Arts Museum, Houston
Carnegie International 1995, Carnegie Museum of Art, Pittsburgh
4th International Istanbul Biennal, Istanbul Foundation for Culture & Arts, Istanbul
Drawing the Line: Reappraising past and present, Whitechapel Art Gallery, London; Southampton City

Art Gallery, Southampton (zusammengestellt von / selected by Michael Craig-Martin)

1994
Drawings: Louise Bourgeois, Asta Gröting, Eva Hesse, Roni Horn, Kathy Temin, Rosemarie Trockel, Rachel Whiteread, Frith Street Gallery, London
Sense and Sensibility: Women Artists and Minimalism in the Nineties, The Museum of Modern Art, New York
Re Rebaudengo Collezione, Radiomarelli, Turin / Torino

1993
Gary Hill and Rachel Whiteread, Rooseum Centre for Contemporary Art, Malmö
Then and Now: Twenty-Three Years at the Serpentine Gallery, Serpentine Gallery, London
Five Works: Keith Coventry, Michael Landy, Bridget Riley, Rachel Whiteread and Alison Wilding, Karsten Schubert Ltd, London
The Sublime Void: An Exhibition on the Memory of the Imagination, Koninklijk Museum voor Schone Kunsten, Antwerpen
Drawing the Line Against Aids, Peggy Guggenheim Collection, Venedig / Venice; The Guggenheim Museum Soho, New York
Whiteness and Wounds: Claudia Cuesta, Sarah Seager and Rachel Whiteread, The Power Plant, Toronto
Turner Prize Exhibition: Hannah Collins, Vong Phaophanit, Sean Scully, Rachel Whiteread, Tate Gallery, London
A Decade of Collecting: Patrons of New Art Gifts 1983–1993, Tate Gallery, London

1992
Doubletake: Collective Memory and Current Art, Hayward Gallery, London

Damien Hirst, John Greenwood, Alex Landrum, Langlands and Bell & Rachel Whiteread, The Saatchi Collection, London
documenta IX, Kassel
Contemporary Art Initiative: Contemporary Works of Art Bought with the Help of the National Art Collections Fund, Kiddell Gallery, Sotheby's, London
Lili Dujourie, Jeanne Siverthorne, Pia Stadtbaumer, Rachel Whiteread, Christine Burgin Gallery, New York
The Boundary Rider, 9th Sydney Biennale, Sydney

1991
Metropolis, Martin-Gropius-Bau, Berlin
Kunst Europa, Kunstverein, Pforzheim
Broken English, Serpentine Gallery, London (kuratiert von / curated by Andrew Renton-Dixon)
Turner Prize Exhibition: Ian Davenport, Anish Kapoor, Fiona Rae, Rachel Whiteread, Tate Gallery, London
Confrontaciones 91: Arte Último Británico y Espanol, Palacio de Velázquez, Centro de Arte Reina Sofía, Madrid

1990
British Art Show, McLellan Galleries, Glasgow; City Art Gallery, Leeds; Hayward Gallery, London

1989
Whitechapel Open, London
Deichtorhallen, Hamburg

1988
Riverside Open, London
Slaughterhouse Gallery, London

1987
Whitworths Young Contemporaries, Manchester

Auszeichnungen / Awards

2004
Kunstpreis der Nord LB / Nord LB
Art Prize

1997
Biennale-Preis für den besten
Nachwuchskünstler / Venice
Biennale Award for Best Young Artist

1996
Prix Eliette von Karajan, Salzburg

1991, 1993
Turner Preis / Turner Prize,
Tate Gallery, London

Bibliografie / Bibliography

**Bücher und Ausstellungskataloge
(Auswahl) /** Selected Books and
Catalogues

2004
Townsend, Chris, The Art of Rachel
Whiteread, London:
Thames and Hudson
Mullins, Charlotte, Rachel
Whiteread, London: Tate

2002
Rachel Whiteread, (Ausst. Kat. /
exhib. cat., Essay von / by Patrick
Elliott), Seoul: Kukje Gallery

2001
Rachel Whiteread, (Ausst. Kat. /
exhib. cat., Essays von / by Lisa
Corrin, Patrick Elliott & Andrea
Schlieker), London: Scottish
National Gallery & Serpentine
Gallery
Rachel Whiteread, Transient Spaces,
(Ausst. Kat. / exhib. cat., Essays
von / by Lisa Denison, Craig Houser,
Beatriz Colomina, A. M. Homes &
Molly Nesbit), Berlin: Deutsche
Guggenheim

2000
Judenplatz. Ort der Erinnerung /
Place of Remembrance, (hg. von /
ed. by Gerhard Milchrahm), Wien /
Vienna: Museum Judenplatz
Sincerely Yours: Rachel Whiteread
(Ausst. Kat. / exhib. cat., Essay von /
by Øystein Ustvedt), Oslo: Astrup
Fearnley Museum of Modern Art

1999
Neri, Louise, Looking Up: Rachel
Whiteread's Water Tower, Public Art
Fund, New York: Scalo, Zurich–
Berlin–New York

1998
Rachel Whiteread, (Ausst. Kat. /
exhib. cat., Essay von / by A. M.
Homes), London: Anthony d'Offay
Gallery

1997
Rachel Whiteread, (Ausst. Kat. /
exhib. cat., Essays von / by Rosalind
Krauss, Bartolomeu Mari, Stuart
Morgan and Michael Tarantino),
Madrid: Palacio de Velázquez,
Museo Nacional Centro de Arte
Reina Sof a
Rachel Whiteread: British Pavilion
XLVII Biennale di Venezia 1997
(Ausst. Kat. / exhib. cat., Interview
von / by Andrea Rose), London:
British Council

1996
Usherwood, Paul, 'The Rise and
Rise of Rachel Whiteread' in: Art
Monthly, 200
Gehrmann, Lucas; Greber, Marianne
(Hg. / ed.), Judenplatz Wien 1996 –
Wettbewerb Mahnmal und
Gedenkstätte für die jüdischen
Opfer des Naziregimes in Österreich
1938–1945, Bozen–Wien: Folio

1995
Tazzi, Pier Luigi, Rachel Whiteread:
Sculpture, Rome: British School at
Rome
Lingwood, James (Hg. / ed.), Rachel
Whiteread. House, (Essays von / by
John Bird, John Davies, James
Lingwood, Doreen Massey, Ian
Sinclair, Richard Shone, Neil
Thomas, Anthony Vidler, Simon
Watney), London: Phaidon

1994
Rachel Whiteread Sculpture, (Ausst.
Kat. / exhib. cat.), Basel:
Kunsthalle, Philadelphia: ICA,
Boston: ICA
Kellein, Thomas, Rachel Whiteread:
Sculptures / Skulpturen, (Ausst. Kat.
/ exhib. cat., Essay von / by
Christophe Grunenberg), Kunsthalle
Basel; Boston: ICA ; Philadelphia: ICA

1993
Made Strange: New British
Sculpture, (Ausst. Kat. / exhib. cat.),
Budapest: Museum Ludwig

1992
Rachel Whiteread: Sculptures,
(Ausst. Kat. / exhib. cat., Einleitung
von / introduction by Stuart Morgan,
Interview mit der Künstlerin von /
conversation with the artist by Iwona
Blazwick), Eindhoven: Stedelijk Van
Abbemuseum

1991
Rachel Whiteread Plaster
Sculptures, (Ausst. Kat. / exhib.
cat., Essay von / by David
Batchelor), New York: Karsten
Schubert Ltd, and Luhring
Augustine Gallery

Autoren

Authors

Mario Codognato freier Ausstellungskurator. Leiter des Ausstellungsprogramms für zeitgenössische Kunst am Museo Archeologico Nazionale in Neapel (u.a. Einzelausstellungen von Francesco Clemente, Jeff Koons, Anish Kapoor, Richard Serra, Anselm Kiefer und die erste Museumsretrospektive über Damien Hirst). Lebt in Rom. Dort Kurator der Richard-Long-Ausstellung im Palazzo delle Esposizioni (1994) sowie der Retrospektive mit Brice Mardens Arbeiten auf Papier in der Calcografia Nazionale (2001), anschließend im Landesmuseum Münster, und weiterer Ausstellungen. Seit 1993 Kurator mehrerer Ausstellungen und Verfasser einer Reihe von Publikationen zum Werk von Jannis Kounellis.

Richard Cork Kunstkritiker (Evening Standard, The Listener, derzeit The Times und The New Statesman), Redakteur (Studio International) und Kunsthistoriker, Radio- und Fernsehjournalist, Ausstellungsmacher. Studium der Kunstgeschichte in Cambridge (GB), Promotion 1978; Slade-Professur in Cambridge (1989–90); Henry-Moore-Dozent (senior fellow) am Courtauld Institute of Art (1992–95); Vorsitzender des Visual Arts Panel beim Arts Council of England (bis 1998). Beiratsmitglied des Paul Mellon Centre und Syndikus des Fitzwilliam Museum, Cambridge. Autor und Moderator zahlreicher Radio- und Fernsehsendungen. Kurator diverser Ausstellungen zur zeitgenössischen Kunst und zu kunstgeschichtlichen Themen (Tate Gallery, Royal Academy, Hayward Gallery, alle London, sowie außerhalb Großbritanniens). Auszeichnungen: Preis des Nationalen Kunstfonds 1995 für die Ausstellung „Art and the First World War" (London, Berlin). Buchpublikationen erschienen bei Princeton bzw. Yale University Press u. a. über „Vorticism" (John-Llewelyn-Rhys-Preis, 1976); Art Beyond the Gallery (Banister-Fletcher-Preis, 1985); David Bomberg, 1987; A Bitter Truth: Avant-garde Art and the Great War, 1994; Jacob Epstein, 1999; Everything Seemed Possible, 2003 (Gesammelte Schriften in vier Bänden); Mercy, Madness, Pestilence and Death (in Vorbereitung, 2005).

Mario Codognato is an independent curator. Since 2001 he has run the contemporary art programme at the Museo Archeologico Nazionale in Naples (exhibitions of Francesco Clemente, Jeff Koons, Anish Kapoor, Richard Serra, Anselm Kiefer and the first museum retrospective of Damien Hirst). In Rome, where he lives, he has curated, among others, museum shows of Richard Long 1994 at the Palazzo delle Esposizioni and 2001 a retrospective of Brice Marden's works on paper at the Calcografia Nazionale which subsequently travelled to the Landesmuseum in Münster. Since 1993 he has curated several exhibitions and publications on the work of Jannis Kounellis.

Richard Cork art critic (for the London Evening Standard, The Listener, at present, for The Times and The New Statesman), editor of Studio International, art historian, broadcaster and exhibition organiser. He read art history at Cambridge, Doctorate in 1978. In 1989–90 he was the Slade Professor at Cambridge, and from 1992–95 the Henry Moore Senior Fellow at the Courtauld Institute. He then served as Chair of the Visual Arts Panel at the Arts Council of England until 1998. He is now a member of the Advisory Council for the Paul Mellon Centre and a Syndic of the Fitzwilliam Museum, Cambridge. He has organised major contemporary and historical exhibitions at the Tate Gallery, the Royal Academy, the Hayward Gallery and elsewhere in Europe. His international exhibition on 'Art and the First World War', held in Berlin and London, won a National Art Fund Award in 1995. His books, published by Princeton and Yale University Press resp., include a two-volume study of Vorticism (John Llewelyn Rhys Prize, 1976); Art Beyond the Gallery (Banister Fletcher Award for the best art book in 1985); David Bomberg, 1987; A Bitter Truth: Avant-garde Art and the Great War, 1994; Jacob Epstein, 1999; and Everything Seemed Possible, a four-volume collection of his writings on modern art, 2003. He is now completing Mercy, Madness, Pestilence, and Death.

Richard Noble lehrt Philosophie und Critical Theory am Goldsmiths College und am Sotheby's Institute of Art in London. Publikationen: zahlreiche Essays, in jüngster Zeit zu David Batchelor, Michael Craig-Martin und zur Beziehung zwischen Kunst und Politik in der liberalen Demokratie; Monografie über Antony Gormley (in Vorbereitung).

Juhani Pallasmaa seit Anfang der 1960er Jahre als Architekt in Helsinki tätig (1983 Gründung des Büros Pallasmaa Architects) sowie als Stadtplaner, Produkt- und Grafikdesigner. Vorträge und Lehrtätigkeit in Europa, Nord- und Südamerika, Afrika und Asien. Direktor des Finnischen Architekturmuseums, Helsinki (1978–83), Professor an der Technischen Universität Helsinki (1991–97), Rektor des Instituts für Industriedesign, Helsinki. Gastprofessuren (u. a.) an der University of Virginia (1992), Yale University (1993), Washington University in St. Louis (1999–2004). Zahlreiche Veröffentlichungen in zwanzig Sprachen, u. a. Encounters: Architectural Essays, Helsinki 2005; Sensuous Minimalism, Peking 2002; The Architecture of Image: Existential Space in Cinema, Helsinki 2001; Alvar Aalto: Villa Mairea, Helsinki 1998; The Eyes of the Skin, London 1996; Animal Architecture, Helsinki 1995.

Richard Noble teaches philosophy and critical theory at Goldsmiths College and Sotheby's Institute of Art in London. He has recently published essays on David Batchelor, Michael Craig-Martin and the relation between art and politics in liberal democracy. He is the author of a forthcoming monograph on Antony Gormley.

Juhani Pallasmaa has practised architecture since the early 1960s and established his office Pallasmaa Architects in 1983. In addition to architectural design, he has been active in urban, product and graphic design. He has taught and lectured widely in Europe, North and South America, Africa and Asia, and published books and numerous essays in twenty languages. Pallasmaa has held positions as eg. Director of the Museum of Finnish Architecture (1978–83), Professor at the Helsinki University of Technology (1991–97), and Rector of the Institute of Industrial Arts, Helsinki. He has also held visiting professorships e.g. at the University of Virginia (1992), Yale University (1993), and Washington University in St. Louis (1999–2004). His books include: Encounters: Architectural Essays, Helsinki 2005; Sensuous Minimalism, Beijing 2002; The Architecture of Image: Existential Space in Cinema, Helsinki 2001; Alvar Aalto: Villa Mairea, Helsinki, 1998; The Eyes of the Skin, London 1996; and Animal Architecture, Helsinki 1995.

Impressum

Colophon

Die Publikation erscheint anlässlich der Ausstellung
This volume is published in conjunction with the exhibition

Rachel Whiteread
9. April bis 29. Mai 2005 April 9 to May 29, 2005

Ausstellung / Exhibition
Rachel Whiteread, Eckhard Schneider

Kunsthaus Bregenz
Direktor / Director: Eckhard Schneider
Kurator / Curator: Rudolf Sagmeister
Kommunikation / Press and Public Relations: Birgit Albers
Assistenz / Assistance: Melanie Büchel
Kunstvermittlung / Art Education: Winfried Nußbaummüller
Assistenz / Assistance: Constanze Wicke
Publikationen / Publications: Katrin Wiethege
Assistenz / Assistance: Caroline Schilling
Technik / Technical Asistance: Markus Unterkircher (Leiter / Head),
Markus Tembl, Stefan Vonier
Assistentin des Direktors / Assistant to the Director: Beatrice Nussbichler
Sekretariat / Office: Margit Müller-Schwab
Administration: Ute Denkenberger

Der besondere Dank der Künstlerin gilt: Eckhard Schneider und allen Mitarbeitern des Kunsthaus Bregenz für ihre Professionalität und Freundlichkeit; Hazel Willis dafür, dass sie im Atelier immer die Ruhe bewahrt; Mario Codognato, Richard Cork, Richard Noble und Juhani Pallasmaa für ihre gedankenreichen Essays; Phil Brown, Katy Dexter und Al Dexter für ihre unermüdliche Mitarbeit und Hilfestellung in technischen Dingen; Mark Francis, Cristina Colomar und allen Mitarbeitern der Gagosian Gallery; Roland Augustine, Lawrence Luhring, Claudia Altman-Siegel und allen Mitarbeitern der Luhring Augustine Gallery; allen Leihgebern, die diese Ausstellung begeistert unterstützt und dem Kunsthaus Bregenz Werke aus ihrem Besitz zur Verfügung gestellt haben – und schließlich, ganz besonders, Marcus Taylor und Connor Taylor-Whiteread für ihr Dasein.

With special thanks from the artist to: Eckhard Schneider and everyone at Kunsthaus Bregenz for their professionalism and kindness; Hazel Willis for her calm in the studio; Mario Codognato, Richard Cork, Richard Noble and Juhani Pallasmaa for their thoughtful essays; Phil Brown, Katy Dexter and Al Dexter for their continued technical support and assistance; Mark Francis, Cristina Colomar and all at Gagosian Gallery; Roland Augustine, Lawrence Luhring, Claudia Altman-Siegel and all at Luhring Augustine Gallery; all the lenders who have enthusiastically supported this exhibition by agreeing to lend their works to Kunsthaus Bregenz – finally, a very special thank you to Marcus Taylor and Connor Taylor-Whiteread for just being there.

Katalog / Catalogue

 Herausgeber / Editor: Eckhard Schneider
 Form und Typographie / Form and Typography: Walter Nikkels
 Assistenz / Assistance: Neil Holt
 Redaktion / Editorial Work: Caroline Schilling
 Lektorat / Text Editing: Claudia Mazanek, Katrin Wiethege
 Fotografie / Photography: Mike Bruce, Gate Studios, London
 Installationsfotos / Installation views: Nic Tenwiggenhorn
 Übersetzungen / Translations: Wolfgang Himmelberg,
 Markus Klammer, Henry Martin, Annette Wiethüchter
 Lithographie und Druck / Reproduction and Printing:
 Druckerei Heinrich Winterscheidt GMBH, Düsseldorf

Verlag der Buchhandlung Walther König, Köln
 Ehrenstraße 4, D-50672 Köln
 T (+49-221) 205 96-53, F (+49-221) 205 96-60

Vertrieb außerhalb Europas / Distribution outside Europe:
 D.A.P. / Distributed Art Publishers
 155 Sixth Avenue, 2nd Floor, New York, NY 10013, USA
 T (+1-212) 627-1999, F (+1-212) 627-9484

ISBN 3-88375-935-x

Erste Auflage 2.000, April 2005
First Edition 2,000, April 2005

Sponsoren der
KUB *Arena*

Haussponsor des
Kunsthaus Bregenz

 Vorarlberg *unser Land*

MONTFORT ⚑ WERBUNG
DMG

 Hypo Landesbank

ZUMTOBEL STAFF

 BRITISH COUNCIL